THE CAT

THE CAT ON A HOT THIN GROOVE

A NOTE FROM THE AUTHOR

The Cat in this book has nothing to do with felines, but his title seems to derive from a West African word, KATTA, meaning a human or person. It may also have Afro-Asian connections with a Nubian word, KADIS, and even an old Germanic word, KATTUZ, both of which did have a feline meaning, but also slang use as a "fellow" or "guy." By the late 1920s and early 1930s it came to mean a "jazz enthusiast." If you listen to early Louis Armstrong records, he frequently refers to his musicians and listeners as "cats." A white guy earned the title "Cat" either by playing or listening to righteous jazz, and that's exactly my Cat!

· ·

Original cartoons by **Gene Deitch** | Edited by **Gary Groth** | Original design by **Joe Preston** | Reprint design & production by **Emory Liu** | Title lettering by **Nomi Kane** | Archival material courtesy of **Glenn Bray** | Associate Publisher: **Eric Reynolds** | Published by **Gary Groth** & **Kim Thompson**

I WANT TO THANK all of the collectors who have cared for my original drawings, and the present day jazz magazines that have continuously reprinted them, and those who have supplied me with copies; my son Kim, only 19 years younger than me, and himself a great and famous cartoonist, who thought up the funny and perfectly apt title of this book. I wish it was my idea! And of course, my great thanks goes to Gary Groth for investing in the production of the book and for rounding up the rare mint copies of *The Record Changer* magazine, from which the reproductions have been derived; and to Robert Crumb for initiating the project and for needling Gary into doing it!

Over and above everyone else, I extend my great thanks to Glenn Bray, without whom this book could hardly exist. Glenn made available to Fantagraphics his extremely rare complete collection of original *Record Changer* magazines containing my drawings. From these mint copies, Fantagraphics was able to reproduce all of the *RC* graphic material you see in this book. I myself have only about 8 dog-eared copies of *The Record Changer*, and no original Cat-toons at all that were published in the magazine. Glenn is the kind of fan who really means something. He came up with the goods. Many, many thanks, Glenn!

FOREWORD

The Record Changer, although not really a prime candidate for consideration as the most unusual little magazine of all time, was certainly in the top handful of oddball American publications of the mid-20th century. And in its own highly specialized field — which was jazz — it occupied the kind of nervously honored position that one might reserve for a rather unstable favorite uncle who was unquestionably very intelligent but also was probably quite insane.

The entire life span of the publication was little more than a decade and a half, and it began simply as a list mailed out by a Washington, D.C. jazz record collector named Gordon Gullickson. The earliest issue in my possession, dated June 10, 1941 and not carrying any magazine title, offers for sale a number of old jazz records. By January of 1943 it had been named and was a stapled, 5" x 8" eight pager. This issue consisted mostly of record lists but included a review of "the outstanding jazz records of 1942" by Nesuhi Ertegun, a son of the Turkish ambassador to this country and later a noted jazz record producer and one of the founders of Atlantic Records. By March, 1945, it was a full 8" x 11" magazine with several well known jazz writers listed as contributors. From then until its demise in 1957, it looked and felt and could be read as an erudite but usually badly written scholarly magazine. And if you thought its published biographical articles and critical diatribes were badly written, you should have seen the original manuscripts. I know, because I definitely did see them, after a while every single ungrammatical one of them, in that form. From early 1948 until late in 1956, I was (perhaps as punishment for sins committed in a former life) the magazine's managing editor.

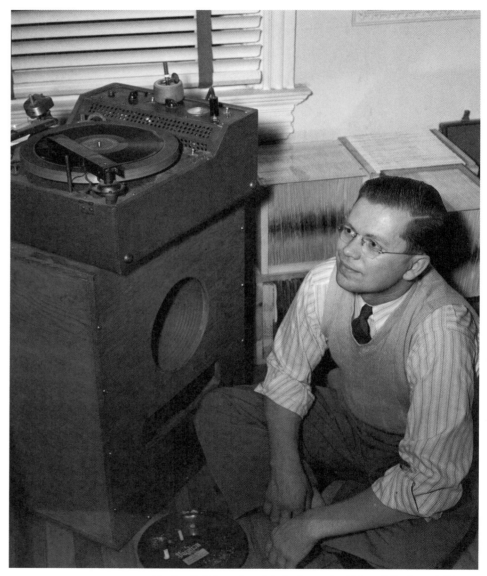

Gordon Gullickson, the original editor and publisher of *The Record Changer*

The aspect of that job most directly relevant to my present task (which is to tell you something about the relationship between the *Changer* and The Cat) was that it brought me into close contact with the devastatingly accurate cartoons and quietly surreal cover illustrations regularly contributed by an obviously brilliant young artist named Gene Deitch. The word "contributed," I hasten to point out, has more than one meaning — and at least two of them are applicable. Virtually the entire contents of the magazine — articles, columns, cartoons — were in general published because they were on hand, having been confidently submitted — contributed — by their authors. Almost never did we request or assign an article, or suggest subject matter for a columnist. And regarding the way you might apply the word on your income tax return, defining "contribution" as a free-will offering given to a non-profit organization, you must understand that, to the best of my knowledge, in the entire history of the magazine, no writer or graphic artist ever received direct financial compensation for his work.

Gene was already well established at the *Changer* before I joined in, but with the passage of time I have undoubtedly become the leading living expert on the subject — which means that there is hardly anyone around to dispute my account. Besides, I am in possession of an almost complete collection of the magazine, so the chronology I am about to offer is the result of some fascinating and just-concluded re-exploration. To begin with a surprise, the first appearance by Deitch was not art, but prose. In the October 1945 issue we find his name listed in the table of contents on the cover, and on page 9 there is a satirical piece announcing a Hollywood movie telling the real history of jazz ("...several stevedores set down their cotton bales and turn out to be the King Cole Trio, piano and all..."). The real breakthrough, however, came in the December issue, with the first of a long line of cover illustrations signed by G.D. And a change on the masthead — Don Anderson, who had created almost all earlier covers, is now joined by Gene Deitch as a two-man "Art Department." And of equal consequence, a cartoon showing the hairless, bespectacled man not yet identified as The Cat, but in the caption wistfully announcing a clear-cut philosophy: "Here I had a complete collection and then what happens! They have to go and discover Bunk Johnson."

January of 1946 brings what I have always considered the first classic Deitch cover: the African-American janitor (his job status clearly identified by the nearby bucket and mop) playing the huge and incredibly ornate pipe organ. Thereafter, the remarkable pace continues. To my delight, there are no less than three Cat cartoons in the May issue. Included is one of my all-time favorites: seated together on a small sofa are the collector and a young woman who is obviously exasperated at being told: "Gad, the resurgence of the New Orleans style is a stimulating development!" And in the caption to another, our hero is referred to, in passing and without capitalization, as "the cat."

August of this year offers two more landmarks. For one, there finally is the first formal identification of the character: A bold heading over each of three cartoons

in this issue finally gets around to formally announcing that this is "The Cat." And in an account that begins on page 8, Mr. Deitch himself tells us who and what he is (and there is also a photograph revealing that, the total baldness of The Cat notwithstanding, Gene himself had — at the time, anyway — an abundant head of hair). It is here we learn that he was born in Chicago and raised in Hollywood, and that back in '46 he was a member of the art staff of the Columbia Broadcasting System, assigned to the Sales Promotion Department.)

Basically, that was Gene's entrance onto the *Record Changer* scene. About a year later there was a sudden significant, if brief, change in the magazine. Gordon Gullickson remained the publisher with a Washington, D.C. address, but as of the August 1947 issue, the editorial offices were in Hollywood and Nesuhi Ertegun was "Editor." Deitch not only remained, but was listed as "Art Editor" in this issue and as the more all-inclusive "Art" in the next two; and with the relocation to his West Coast home territory, he was all over the place. In addition to covers and cartoons, The Cat was the central figure in the inside front cover ads for the Jazz Man Record Shop, and all the internal illustrations and decorative doodads were clearly by Deitch.

But this turned out to be only the prelude to an even more drastic change. The magazine skipped a couple months late in 1947, during which much behind-the-scenes maneuvering was going on, and the very next issue, dated February 1948 (designated Volume 7, Number 2; there was no Number 1) showed the

editor (later also the publisher) to be Bill Grauer, Jr., who had for some time been the New York-based advertising manager. Bill, my former college classmate, had purchased the magazine from Gullickson; I was listed as Managing Editor. Ertegun was "West Coast Editor," but that proved impractical and soon ended. Deitch was "Art Editor," but before long this too was subject to revision. Within a few months, what he did was being specifically credited: under the heading "Art Staff" appeared the line "Gene Deitch, Cover & Cat." This was followed by a "Design & Typography" credit which, from the fall of '48 until well into 1956, belonged to our friend Paul Bacon, who squeezed this into an increasingly busy schedule as one of the book-publishing industry's leading jacket designers. Under these circumstances, Gene's obligation to supply "Cover & Cat" continued to be fulfilled cross-country. (I don't believe I met the man more than once while we were both pursuing partial careers at the same unique publication. We have, however, managed to become closer in recent years. I have not yet made a journey to Prague, where he has lived for a great many years, but he and his wife get to San Francisco almost every year to visit family members, and we are usually able to hook up then. In addition, despite being well into maturity, we are both very much a part of the Brave New World of the computer and stay in touch via e-mail.)

However, after a little more than five years of consistently outstanding covers and cats, the Deitch era at the *Changer* came to an end. It happened suddenly, was thoroughly documented, and was really nobody's fault. There is a lengthy

editorial, written by me, in the February 1951 issue. It is unsigned, but even after a half-century I have no trouble identifying my literary style. It is appropriately headed "Singin' the Blues" (which is the title of an early Bix Beiderbecke record), and it begins by announcing a distressing reality: "With this issue, and undoubtedly for some time to come, *The Record Changer* drastically alters its appearance. It is a change we deeply regret, but one that is completely unavoidable." The cause was rapidly rising production prices, spearheaded by an appalling 75% increase in the cost of printing the magazine. "We have always been quite proud of the fine-looking covers," I continued. "Gene Deitch has always had the 'feel' of jazz and was able to execute his ideas beautifully in color. But this is a luxury we will have to forego." There is no specific mention of The Cat, but he also would never return. It seems clear enough that this very real crisis also provided a suitable occasion for a complete break. Meeting monthly deadlines from roughly 3,000 miles away had never really been easy, and Gene's entry into the rapidly expanding world of television inevitably created further problems. (Deitch had a notable association with the long-running children's program, *Captain Kangaroo*, for which he created two celebrated characters, Tom Terrific and Manfred the Wonder Dog.)

As a final footnote, it should be noted that *The Record Changer* survived its 1951 crisis, but not for too long. It could be described as the eventual victim of a peripheral success that it helped to create. By the end of 1952, Bill Grauer and I had started a shoestring jazz label that we called Riverside Records. Initially housed in the *Changer*'s storefront office just south of Harlem, and deriving its name from the magazine's telephone exchange, it eventually grew into one of a group of highly active independent jazz labels that flourished in New York in that period. But its heavy early demands on the time and energy and attention of both Grauer and myself meant that something had to give. Before the end of 1956, the magazine had been taken over by a knowledgeable jazz enthusiast whose intentions were admirable but who was unable to survive in the post for more than a handful of issues. *The Record Changer*, it now seems clear in retrospect, belonged very much to its own specific era. It was undoubtedly doomed way back when the development of magnetic recording tape and the long-playing record helped create a vast and unending stream of reissue collections that replaced the whole concept of selling and trading and auctioning rare individual records. But the *Changer* sure was fun while it lasted — and the rare talent and sensitivity and wit of Gene Deitch was one of the principal causes of that fun.

ORRIN KEEPNEWS,
San Francisco
January, 2003

THE CAT ON A HOT THIN GROOVE

Okay, so The Cat was me.

In 1945 I was an emerging New Orleans jazz fanatic, having been duly baptized by Marili Morden (later Stuart, later Ertegun) of The Jazz Man Record Shop in West Hollywood, where I lived. In a youthful burst of revelation I entered her shop and proclaimed that I had just discovered the "real jazz" in a recording of Bob Crosby's Bob Cats!

After a pause, during which Marili considered whether it was worth her time to straighten me out, she deigned to play me her rare copy of the Gennett label King Oliver Creole Jazz Band recording of "Dippermouth Blues." "This is the Real Jazz!" she said. Of course, she was right — to this day the 1923 KOCJB has never been equaled, let alone surpassed. From that moment on I was the most doggedly, or CATedly, pure N.O. jazz fanatic of them all.

At the Jazz Man shop I also picked up my first copy of *The Record Changer* magazine... actually, it was just a folder of classified ad listings of rare 78RPM jazz records offered or wanted by collectors. The sheet also had a few purist articles, written by the jazz gurus of the time. It was published by a guy named Gordon Gullickson in Fairfax, Virginia, a Washington, D.C. suburb. That was a far-away and unknown place to me. *The Record Changer* soon became a real magazine, with illustrations and more articles to supplement the classified listings. We must remember, in these times of being able to buy a CD of nearly every recording of any kind, made any time, from anywhere in the world, that in those early post-WWII years, historic jazz recordings were virtually unavailable in any mainline record shops. The rare dusty "platters," as we called them, could generally only be found stacked in unorganized jumbles in the back corners of Salvation Army or Goodwill second-hand shops.

I should note that I am not a musician. I cannot play any musical instrument or even sing in tune. I can pound out rhythm on hand drums, but I don't really know how to keep track of bars or choruses. I rarely frequented clubs where jazz was played, aside from my later relationship with Turk Murphy of the Lu Watters Yerba Buena band and Kid Ory's Creole Jazz Band when they played at the Jade Ballroom on Hollywood Boulevard. No, I just listened to records and collected them. That was my personal jazz experience. I just love the music – not the smoke, sweat, or funky atmosphere of the dives where the great men of jazz played. I was a traditionalist/purist in my taste for jazz music, but on the other hand I was also an emerging cartoonist and designer, hot to try new ideas, with a sense of humor about myself and other jazz fanatics. So I thought up this super-intense character with heavy horn-rimmed glasses of the kind that I began to wear when my distance vision blurred at the age of 20. It was at that age that I sent a couple of my first Cat cartoons to Gordon Gullickson. To my delight he immediately accepted and published them.

It was the start of a wonderful relationship. Gordon's letters were funny. He had a great sense of humor, and in almost every letter he included his pet phrase

to indicate how frantically busy he was. "I'm carrying on like a mouse in a bucket!" he wrote. That was so evocative a line that I took to saying it myself. I loved working with Gordon, though I never once met him or even saw a photo of him. He was the great pioneer in jazz record publishing. From him, from his magazine, and other collectors and players that I met, I picked up the foibles, fetishes, and fixations of the fanatic gaggle of "Mouldy Fygge" record collectors. Their acceptance of the cartoons proved that these people were happy to make fun of themselves. Many sent me gag ideas, which I always credited. For my part, though the activity of drawing the Cat-toons was just a hobby, it was also a great way for me to expand my graphic abilities. After a short while, I began to change the way I drew The Cat, constantly experimenting with new graphic styles. It wasn't like a newspaper comic strip, where the characters had to look identical every day, and could be changed only gradually. (I later did such a daily and Sunday strip myself).

For *The Record Changer* I took a free-wheeling approach, retaining only the oval-shaped, heavy black-rimmed eyeglasses, and the sharp, pointed nose, but constantly changing nearly everything else about how The Cat was drawn, except the flurry of weird symbols which I soon added, and which have ever since always floated around his head to express his seething intensity. I picked up those symbols from a great graphic artist of the time, James Flora, who did promotional leaflets and album covers for Columbia Records. We later became close friends, and I made three films from his children's books.

When Gordon encouraged me to also do the covers for the *Changer*, with the chance to work in two colors, I embarked on my greatest personal development as a graphic artist, basically cribbing and adapting styles from every artist I admired. Nothing I have ever done since was as much pure fun and gratification as working on *The Record Changer* during my years of youthful enthusiasm. I soon set the entire visual style of the magazine, designing its logo and filling it with all sorts of little graphic doodads as well as one or two Cats and the cover designs. My enthusiasm continued until Gordon sadly sold the magazine to its business manager, Bill Grauer, Jr., in 1950. I didn't have the same rapport with Bill. I met him personally when I moved to New York in 1951. He burst my bubble by saying that as far as he was concerned, *The Record Changer* "was just a business." I was dismayed. It had never been a business for me. It was love. Even worse was that under Grauer *The Record Changer* was no longer a purist, traditional New Orleans jazz journal, but was even opening its pages to Bebop and Modern Jazz!!! That was beyond my tolerance level! So that was the end. I quit. But over the years, as I did many other things, and even won an Oscar for one of my movie cartoons, the memories of my *Record Changer* days were always with me, and I became amazed and gratified at how my old Cat-toons had become jazz memorabilia icons and collectors' items. I don't own a single original myself. I found that they were being bought and sold and traded, and that even though I had made a successful international career as an animation film director, many (old) people know me only for those old Cat-toons!

The Record Changer

That's an odd name for a magazine if we think about it in today's terminology. Neither of the key words, "record" and "changer," apply to the playing of music today. We have "discs," "tapes," and solid-state storage of music on such hi-tech gadgets as MP3 players and memory sticks.

My design of *The Record Changer* logo, introduced in 1946, was the first to illustrate the obvious double meaning in the magazine's moniker. An actual record changer was a mechanical apparatus that allowed you to stack up to ten shellac records on its tall spindle, which would drop one by one onto the turntable after each was played… all automatically! Those old records played only a maximum of three minutes, so a record changer gave you a chance to stay seated and be able to listen to up to ten records before you had to get up again.

But those record changers were persnickety machines, often getting stuck and increasing the chances of record damage or even breakage. Serious collectors shunned The Record Changer machines, but avidly read *The Record Changer* magazine! From its inception the name was a small joke about the magazine's initial purpose, the buying, selling, auctioning, and exchanging of rare jazz records. It was at first only a folded sheet. Articles and jazz information were only gradually introduced in a magazine format of stapled pages, becoming a serious compendium for serious collectors of what we considered to be serious music. And then I came along,

trying for an overall graphic styling to add a little cheer to our serious passion, and introducing a series of "Cat-toons," intended to make some fun of ourselves.

"Records," in the time of *The Record Changer* magazine's heyday, the 1940s and '50s, referred to brittle shellac discs, either 10 or 12 inches in diameter, with an all-important label sealed into the center, which turned on a rotating "turntable" at the plus-minus speed of 78 revolutions per minute. The actual music was pressed into them in the form of a spiral groove, with wiggles preserving what we now call an analog recording.

The grooves were big enough to see without magnification. They were physical. You could, as I did for fun, stick an ordinary straight pin into a playing card, which became a crude amplifier when you lowered the pin onto the rotating disc. You could actually play the music that way, with just a straight pin and the Jack of Diamonds!

Of course, no rare jazz record collector in his right mind would ever do that with a disc of any importance. No, the playing of shellac jazz records was a ritual of religious intensity. The fragility of that medium caused collectors to take extraordinary measures to protect their sacred objects. There was no such thing as "burning" CDs, or making credible copies. It was vital to preserve what you had. The ordinary record players of the time used metal needles, screwed into heavy pick-up arms. If one neglected to change the needle after each and every play, the disc would be worn out

after ten plays. Even a new 78RPM record, played on a phonograph or gramophone of the time, sounded like listening to music while riding in the caboose of a freight train. "Surface noise" is what it was called, and every attempt was made to reduce it. But even the early electric record players with so-called "tone-control" gave you a no-win trade off. If you wanted to hear whatever treble notes there may have been on the records, you would have to turn the tone control all the way to the treble side, where you would also hear the maximum of the hiss and click of the surface noise. If you turned the control to the bass side, the music sounded as if it were coming from under a pile of your dirty laundry: muffled.

As I noted above, the records were made of something called shellac before there was such a thing as vinyl. I was told that shellac was made of crushed beetles, as was the shellac then used for adding gloss to furniture, etc. But this record shellac was more like tar, made black with something called lampblack — soot — and a hot glob of it was put on a press, on to which was mounted metal "mothers," which were in turn cast from metal masters somehow molded from the original recordings carved on wax by a vibrating recording needle, activated either by a giant horn into which the musicians directed their efforts, or later by an electrical impulse summoned up by something called a microphone. Isn't it a miracle that so much glorious music was preserved in this way?

So all of us treated these black platters with lavish care and respect. We used counter weights, and springs to reduce the weight of the heavy pickup arms. We even went so far as to grow cactus needles, which we hoped would wear out before the records did. We even had little widgets that rotated the cactus needles on sandpaper discs so they could be resharpened after each play!

We carefully stored our precious discs in heavy cardboard slip covers. The paper envelopes the discs were sold in offered no protection from breakage, only from surface scratches. Once a disc — heaven forfend! — was cracked, it was finished. There was no possible repair, and playing a cracked disc sounded like the crack of doom. Even a collector's anguished tears could not weld it.

The fragile nature of 78RPM shellac discs prompted *The Record Changer*'s famous rating system for the records offered or requested. All records listed in the classified ad section of the magazine were rated N (new), E (excellent), V (very good), G (good), F (fair), or P (poor). Such nuance was highly subjective, but every advertiser was on his honor to provide (near) truthful ratings. But who would buy a P quality record? No problem, if the music thereon was E!

Later, when vinyl plastic appeared, and then 33.3RPM LP (long playing) records appeared, even more elaborate measures were taken to preserve the grooves, which were barely visible to the naked eye, and therefore even more delicate. And though the vinyl records were touted as being unbreakable and thus eternal, they were in fact even more prone to scratches, pops, and static dust after only a few plays. All kinds of anti-static potions and cleaning pads were developed,

none of which really worked. And the needles were no longer called needles, but "styli" ("stylus," singular), and graduated from rare metals to sapphires to diamonds, ground and polished to mini-microns of accuracy, so as to nestle smoothly into the invisible microgrooves.

Elaborate card catalog cross-reference filing systems were developed for the constantly growing collections. A true jazz compiler could find any disc by instrument, by title, by artist, by composer, by label, by date, by matrix number, or even by rumor that an obscure horn blower might have appeared on such-and-such a recording gig…. and all without computers!

So it went, and it was my role to attempt to brighten the high-strung but lo-fi world of rare jazz record collecting. My cover designs and Cat cartoons all referred in one way or another to the basic conditions I have just described. It was a fanatic's world, and I was one of the fanatics.

Gene Deitch,
Prague, 2003

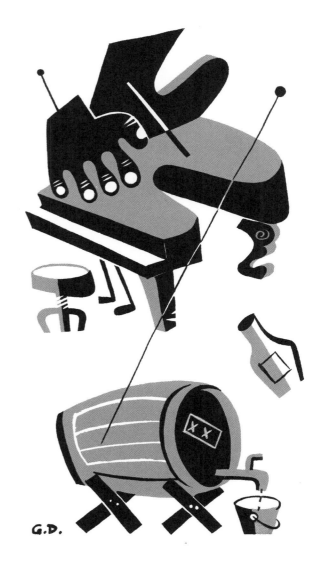

1945

—DECEMBER 1945—

This stylized profile of a dazzled jazz record listener was my first *RC* cover design. It was directly influenced by the work of James Flora, who was doing promotional leaflets and album covers for Columbia Records. I was mad for his style, and went to my local record shop to pick up each month's Columbia release booklets. The flowery fireworks floating around the stylized head on this cover were typical of what he did. Trying to describe what they were, Jim called them "plewds & briffits." I soon began using variations of these little doodads floating around The Cat's head as symbols of his fervid, fanatic brain.

18

The early Cat-toon from page 7 of this issue was still without the "plewds & briffits." It was a comment on the ambition of many collectors to have a "complete collection" of every jazz record ever made; always a chimera. The second Cat in this issue has him in full flower, gushing his newly learned musicologist jargon to a decidedly put-off jazzman.

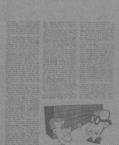
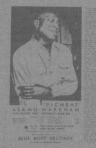

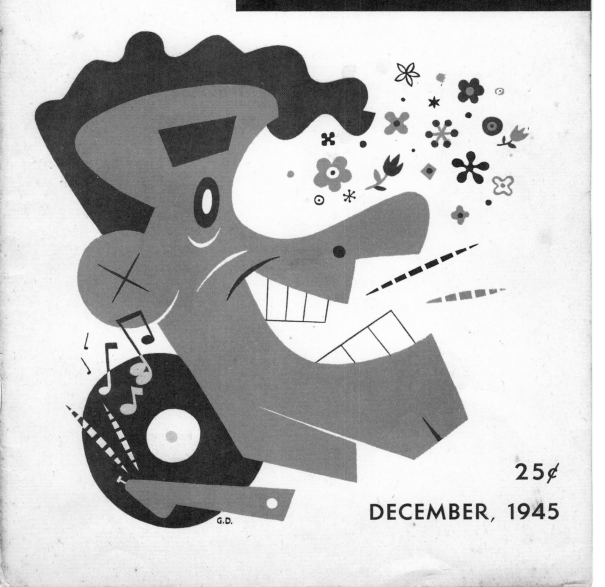

records for sale.
records wanted.
jazz news &
analysis

THE RECORD
CHANGER

25¢

DECEMBER, 1945

"HERE I HAD A COMPLETE COLLECTION, AND THEN WHAT HAPPENS!---THEY HAVE TO GO AN' DISCOVER BUNK JOHNSON!"

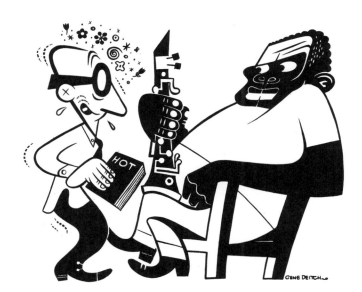

"IS IT TRUE, MR. NEEZER, THAT DURING THE DECLINE OF YOUR 'STACCATO' PERIOD, THAT YOUR CONTRAPUNTAL ATTACK AND POLYRHYTHMIC PATTERNS EMBODIED CERTAIN 'DODDSIAN' INFLUENCES?"

1946

I had just recently, for the first time, heard the magnificent pipe organ recordings of Fats Waller and imagined a portly black church janitor setting down his mop and bucket and rolling out some mighty blues in the midnight of an empty church on an elaborate organ most likely sanctified for an entirely different kind of music. This drawing was reproduced many times over the years without anyone ever asking permission, and I was tickled to find it once on an actual Fats Waller album cover!

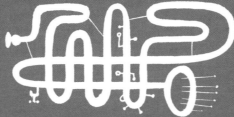

22

A popular term for traditional Negro jazz and folk songs of the time was "Protest Music." We white collectors often searched for the hidden meanings in this music, protesting slavery, segregation, and all the other degradations Black Americans suffered. We felt this "protest symbolism" to be present only in true Black American music, and absent in the white imitations. So The Cat in this issue puts down white Chicago jazz as having "no protest" in it.

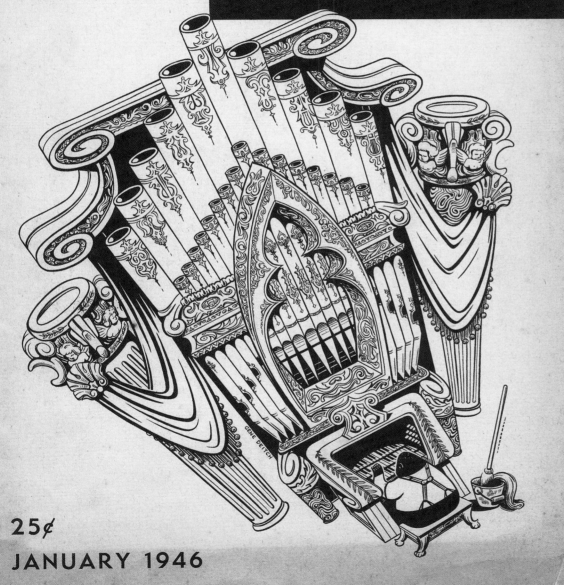

THE RECORD
CHANGER

records for sale.
records wanted.
jazz news &
analysis

25¢

JANUARY 1946

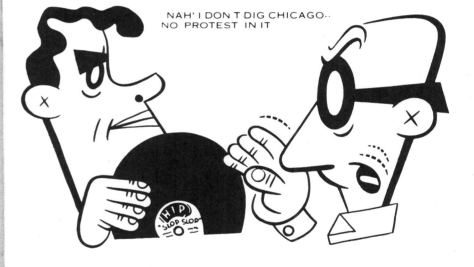

Here I was having fun doing a rip-off of Salvador Dali's surrealist symbols. The mighty black arm rises from folk roots, breaking the chain of slavery. It holds the record-playing "tone arm," supported by a tuning fork, and transmitting the musical message of the Black Man. Flopped over it is a limp, shellac record (parodying, of course, Dali's limp watches), marked, in *Record Changer* code, "Very Good to Excellent," which all true jazz was. A forlorn white Victor dog is way out of it, still listening to "His Master's Voice." A trombone hangs from the crescent moon, symbolizing the Crescent City of New Orleans, the cradle town of jazz. Below, a wandering ear searches for the true sound. A saxophone grows like a fungus from the righteous black arm. (We still didn't accept the sax as a "true" jazz instrument.) On the ground is a Valentine (it was February!) to a "Moldy Fig," the self-derogating term for ourselves, who would accept only pure folk jazz. And lying quietly on the left is the most subtle symbol of all, a feather, referring to the Antichrist critic, Leonard Feather, who dared to impose modern jazz into our tightly sealed world! I thought this cover was a good joke, but many took it seriously.

Inside were two Cat comments on the fantasy brains of the true believers.

24

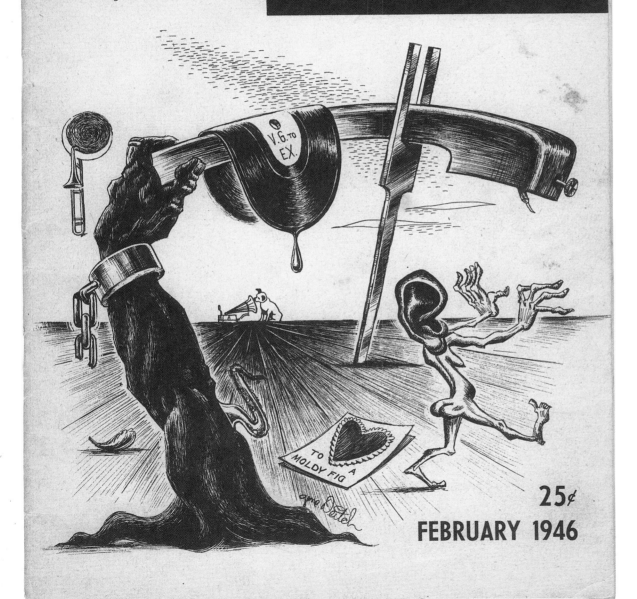

records for sale.
records wanted.
jazz news &
analysis

THE RECORD
CHANGER

25¢

FEBRUARY 1946

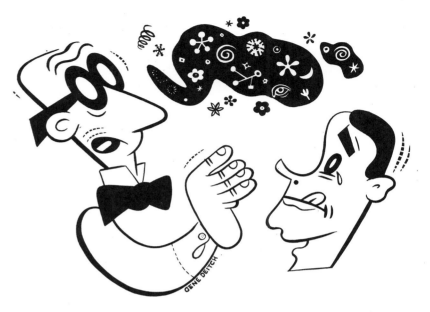

"Then Ory put a 'Gliss' on F sharp—and everything went black!"

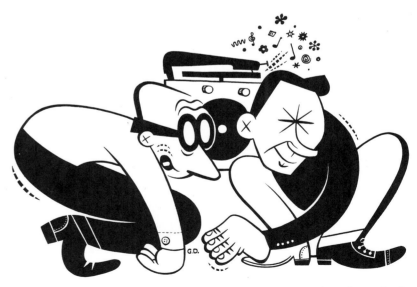

" 'Mellow-Lips' Jaxon was in the studio on this recording date—if you listen closely you can hear him sneeze during the third chorus!"

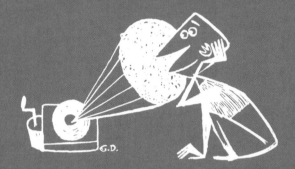

I missed doing a cover for this issue, but revealed The Cat doing a little cheating as he attempts to improve the appearance, if not the sound, of a record he'd like to trade off as being of a higher quality rating. In the second cartoon he peers into a microscope to catch another collector trying to cheat him. There were indeed some highly tuned experts who could claim to read the vibrations on a 78RPM record!

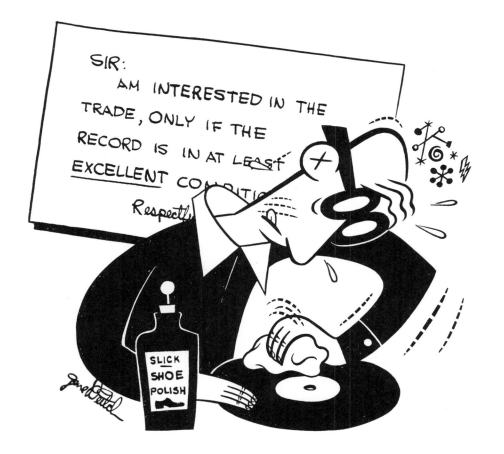

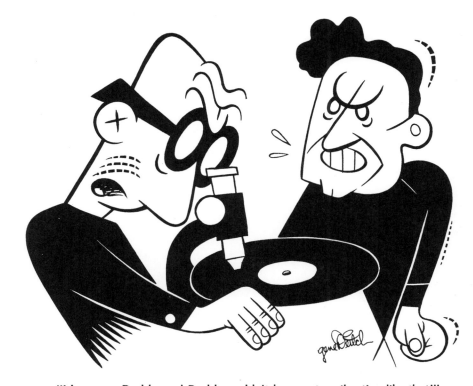

"I know my Dodds, and Dodds couldn't have cut a vibration like that!"

This is a reasonably close image of the old Jade ballroom on Hollywood Boulevard, which inexplicably introduced an oriental atmosphere to New Orleans Jazz. But I didn't quibble about that. It was the first gig of the newly reconstituted Kid Ory Creole Jazz Band, and I hung out there at every opportunity. It was one of the glory moments of the post-WWII jazz revival, and Kid Ory, having had the great luck of being featured on Orson Welles' weekly radio show, which gave rebirth to his band, went on to have a triumphant second career.

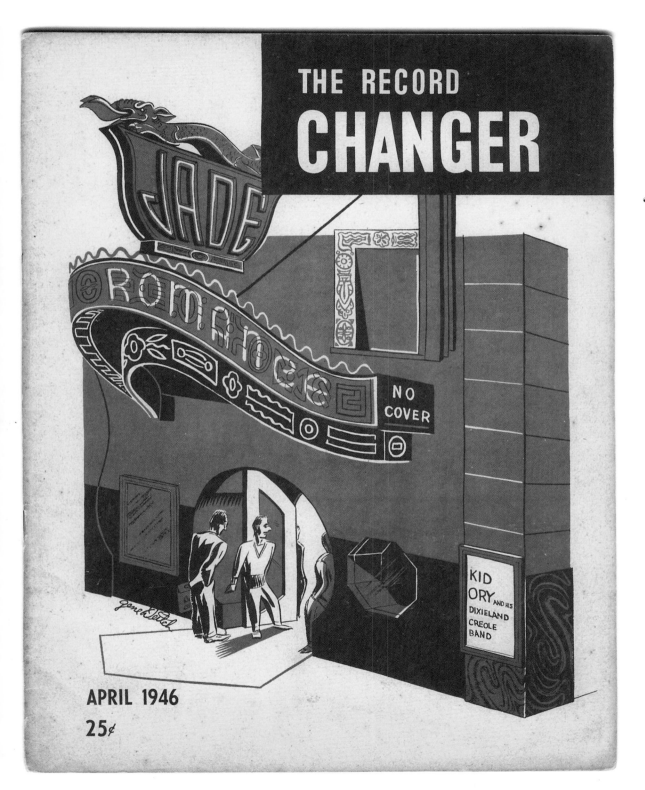

THE RECORD
CHANGER

JADE

NO COVER

KID
ORY AND HIS
DIXIELAND
CREOLE
BAND

APRIL 1946
25¢

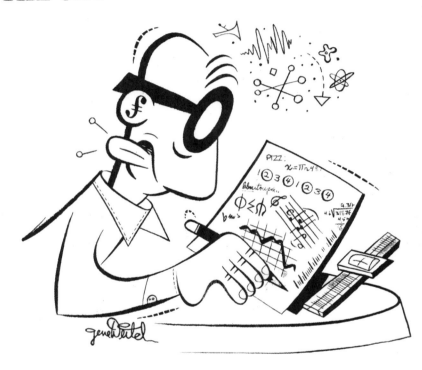

"THE CAT"

Eurekal Now the superiority of New Orleans Jazz can be contrapuntally proven!

I had three cartoons. In one, The Cat shows us that the refined collector zeroed in not only on tunes, but on specific alternate studio takes, which were sometimes issued without any notice by the record companies that they were in fact alternate renditions. But the sharp-eared collector-sleuths would refer to privately published matrix indexes, prompting them to rummage through stacks of discs to find specific obscure takes, indicated only by the faint matrix numbers pressed into the discs near the labels.

The second Cat drawing in the May, 1946 issue shows him lying prostrate after the hopeless task of notating a high-speed piano rendition by Jelly Roll Morton. The third indicates that even a female bosom takes second place to the sexual attraction of jazz!

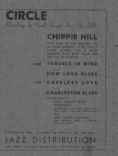

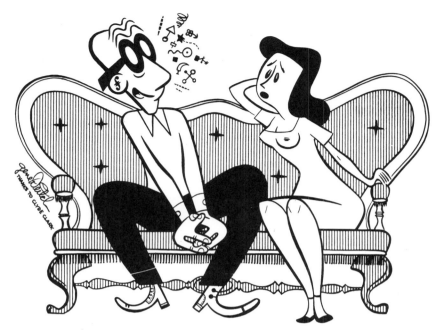

"Gad, the resurgence of the New Orleans style is a stimulating development!"

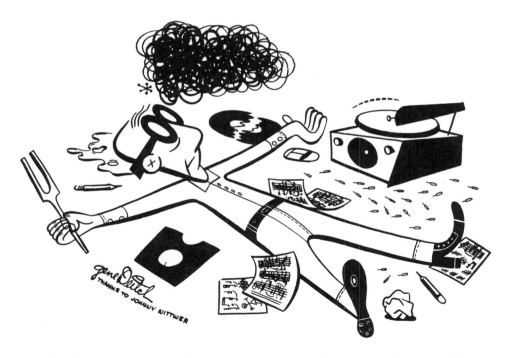

The "cat" after trying for three hours and thirty-two minutes to notate Morton's "Fingerbuster."

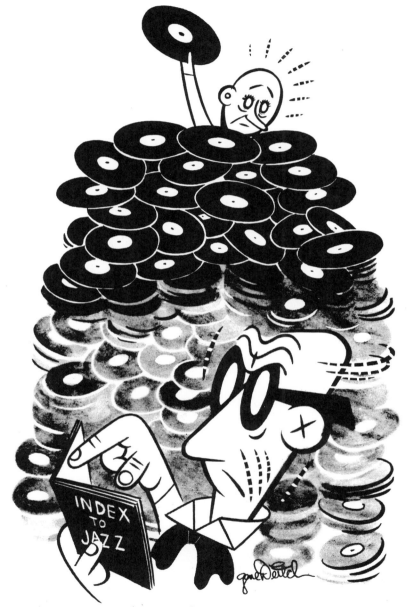

"Naw, I don't want that! That's the 'A' master which is relatively common!"

This issue's cover is probably my first illustrational drawing for the magazine. The hi-tech-equipped record hunter is about to set out on a safari to find elusive rare discs. Note that among his gear is a belt pocket for phonograph needles, some Salvation Army tableware, and a locked box slung from his shoulder with a slot for dropping in the catch.

32

In a Cat-toon our hero, still in the learning phase, moans over his earlier ignorance at having passed on a true jazz disc in favor of a popular swing band item, and then, as he waters his cactus plant, berates an unenlightened fellow collector for using metal needles on his precious and delicate discs. Cactus needles were believed to cause less wear on the grooves of a shellac record.

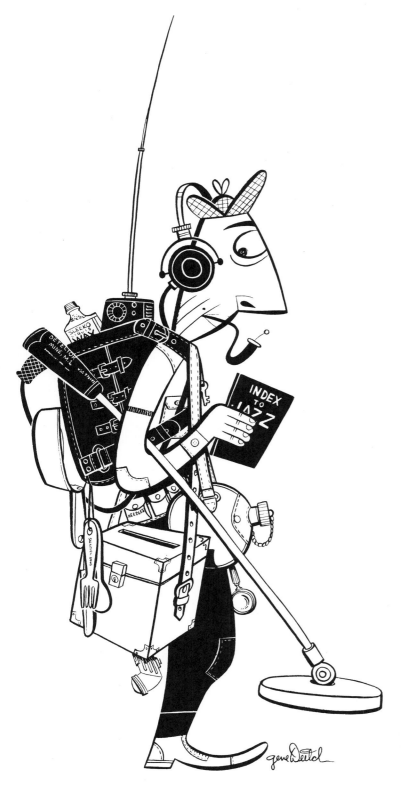

The June, 1946 Cover Illustration.

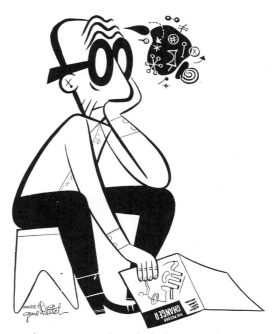

"$20.00 he wants for it . . . And to think that only three years ago . . . three short years . . . I had it right in my hands . . . But did I buy it? . . . No!! . . . I thought it was corny! . . . 'I think I'll take the Harry James record instead,' I says . . ."

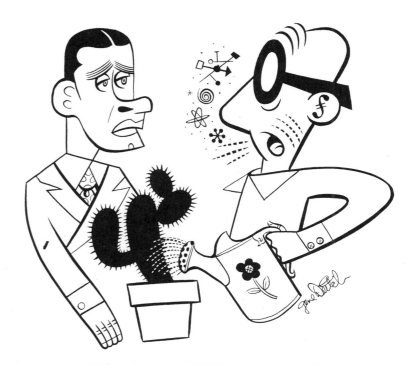

"What! You use NEEDLES on your records?!"

In this issue I rated my first personal mention in the magazine — and even a biography and photo! I was adorned with cardboard Cat spectacles, in Gordon Gullickson's editorial column. And though without a cover drawing by me in that issue, there were four Cat-toons within.

In one, The Cat is devastated by his about-to-be-ex sexy girlfriend, who has committed the unforgivable, the breaking of one of his rare jazz records.

The second is a blatantly partisan blast at the despised Leonard Feather (please forgive me, Leonard, if you are still around and reading this!), transparently disguised as "Braynard Leather," perceived then by we purists as one who was enriching himself by his various promotions of "borderline" jazz.

In the third, The Cat proudly displays one of his records — too rare to actually play!

Finally, The Cat sits in The Jazz Man Record Shop in Hollywood, bemoaning his lack of funds.

34

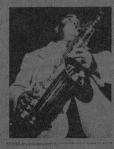

"THE CAT"

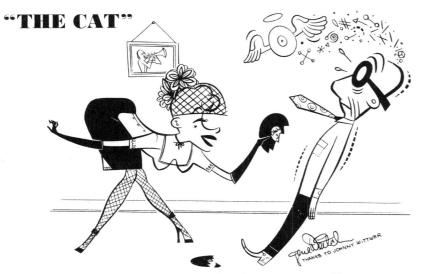

"Geez! Ain't it lucky it was just this old worn out one!"

"THE CAT"

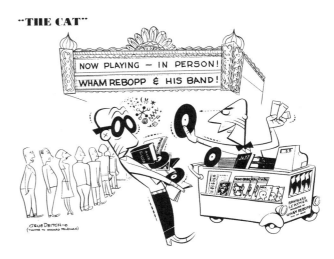

"Here y'are, bud! Get your biography of Wham Rebopp, I wrote it myself; don't miss his latest platter, an original by me; here's the new issue of Monotone Magazine, in which I review the record; have you read my new book on jazz; you'll surely want my latest photograph of the band; and oh yes—here's a couple of passes—on me!"

"THE CAT"

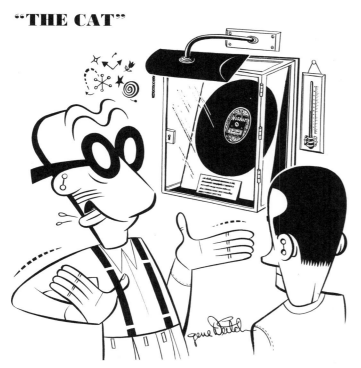

"Here it is! My original 'Happy Brass Deceivers!' I can hardly wait for the reissue to come out so I can hear what it sounds like!"

"THE CAT"

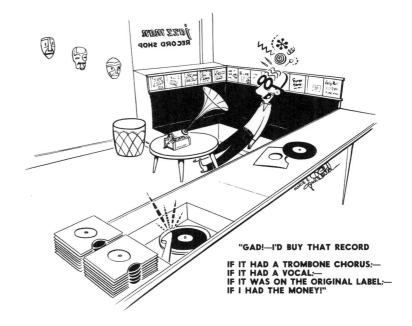

"GAD!—I'D BUY THAT RECORD

IF IT HAD A TROMBONE CHORUS;—
IF IT HAD A VOCAL;—
IF IT WAS ON THE ORIGINAL LABEL;—
IF I HAD THE MONEY!"

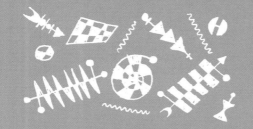

Three Cats in this one. The first indicates that if not hi-fi or stereo in those days, at least we insisted on playing our records LOUD!

The other two Cats depict the musical perfectionist and the card-sharp-type trader, wheeling and dealing for a coveted disc.

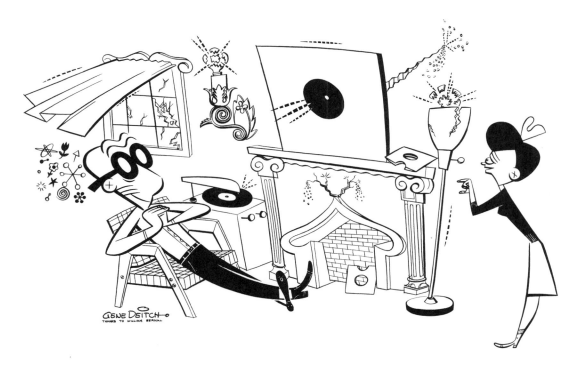

"Dear, couldn't you turn it down, just a little?"

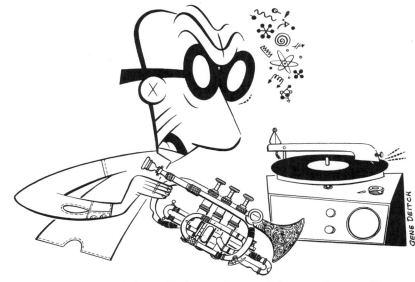

"Dammit, Herbert Clarke, you're not following the score!"

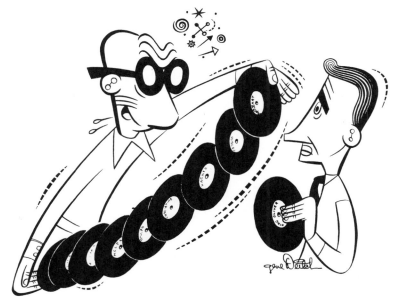

"Tell ya what I'm gonna do . . . !"

This is one of my favorite Cats, as it was even more autobiographical than usual. The wilted ears reflected the stunning blast of the Lu Watters band, which I could hear a block away as I eagerly approached San Francisco's Annie Street and the fabled Dawn Club on several blood-boggling occasions.

Next, my illustration of the challenging task of properly cataloging even a modest collection of jazz records. In those days, long before the advent of computers, the card catalogs could easily be larger than the shelves of discs themselves!

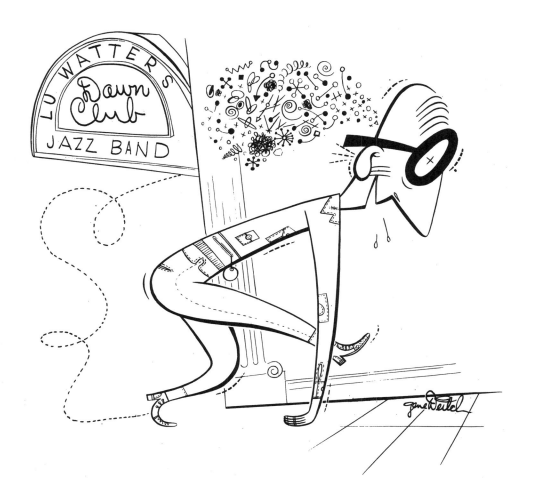

". . . Oh no, this is just the
card index; the records are over there!"

In November I managed to come up with another cover before the year ended, by submitting a portrait from life I had drawn of Mutt Carey while sitting with him at the Jade Ballroom in Hollywood, between sets of Kid Ory's band. I feel this portrait caught his character and nobility.

The two Cats illustrate his distance from reality. The German oompah band obviously did not know the tune, "I Wish I Could Shimmy like My Sister Kate." And The Cat at home had more hazards to his record treasures than a mere needle could save.

record *changer*

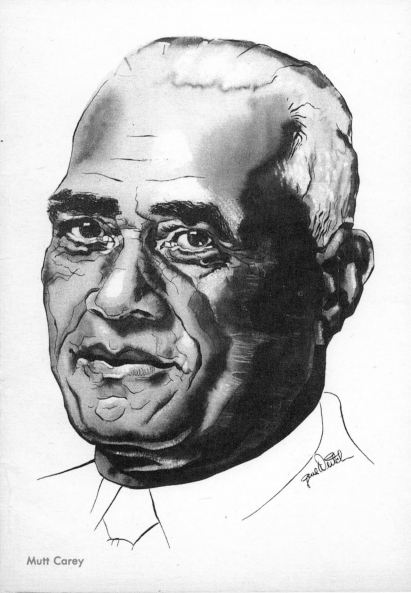

Mutt Carey

25¢
nov. '46

"THE CAT"

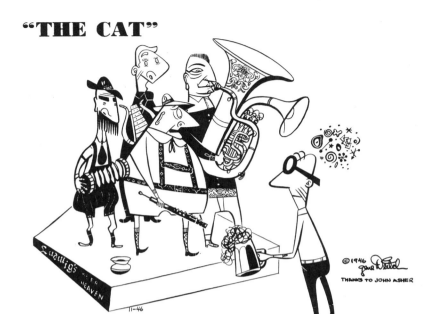

©1946 THANKS TO JOHN ASHER

"Was iss das 'Sister Kate'?"

"THE CAT"

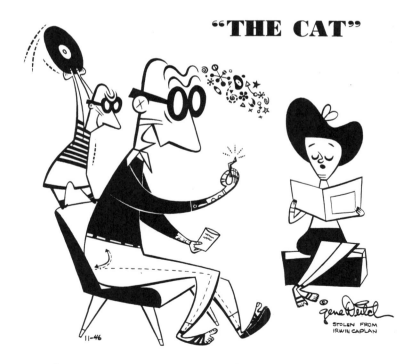

STOLEN FROM IRWIN CAPLAN

"With this new needle, my records will last hundreds of plays longer!"

G.D.

Here, The Cat cannot imagine that there could be a greater Christmas gift for his wife than a rare jazz record. And I also first made a Christmas gag that with variations became an annual feature. The shape of what stuffs his Christmas stocking indicates exactly his ideal dream gift.

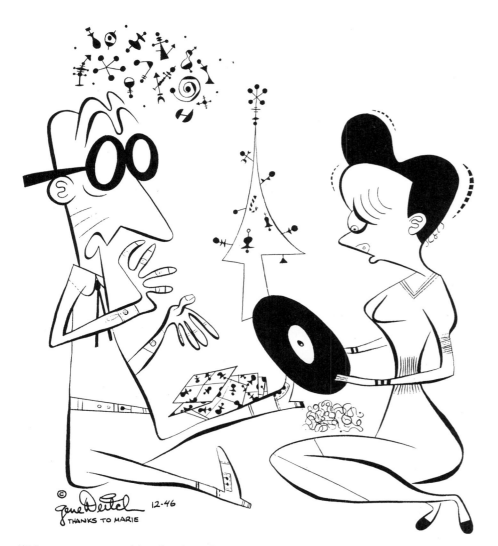

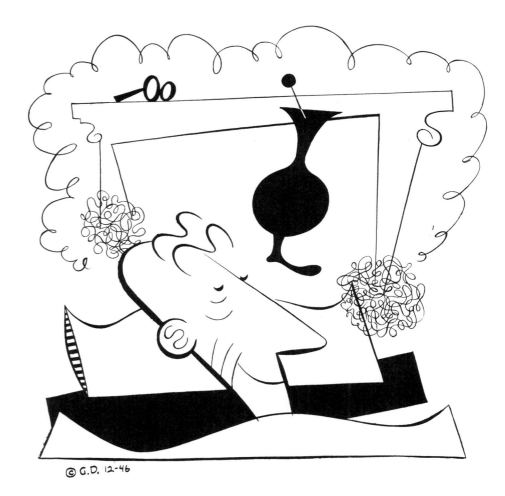

"You mean you would rather have had a fur coat than an original Oliver!!?"

1947

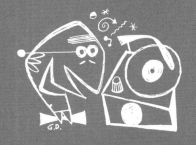

At this time I was confident enough of my animation work to take over the complete design of the *Changer*. I established a new title lettering style, a new logo, and added many decorative noodlings throughout, and began a regular series of cover designs. This one was based on a phenomenon I had noticed in post-war Los Angeles. Many elegant old homes, being expensive to maintain, began to build commercial offices and shops into their ground floors. This one happily sported a record shop!

The Cat shows the proper way to bring up a kid, and then indicates the progression of his jazz perceptions.

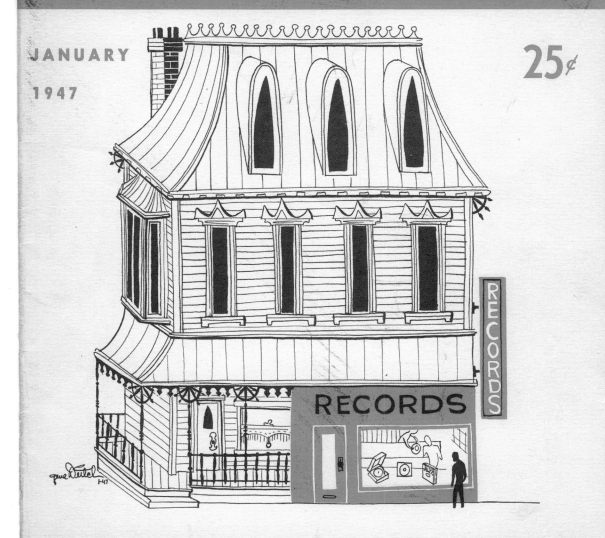

the record changer

JANUARY

1947

25¢

RECORDS

RECORDS

A MONTHLY PUBLICATION DEDICATED TO AMERICAN MUSIC

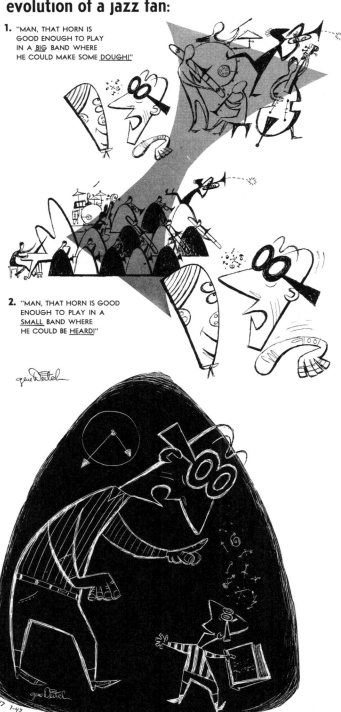

evolution of a jazz fan:

1. "MAN, THAT HORN IS GOOD ENOUGH TO PLAY IN A <u>BIG</u> BAND WHERE HE COULD MAKE SOME <u>DOUGH</u>!"

2. "MAN, THAT HORN IS GOOD ENOUGH TO PLAY IN A <u>SMALL</u> BAND WHERE HE COULD BE <u>HEARD</u>!"

"OK, OK. If you hurry and get ready for bed, I'll read you another chapter of Rudi Blesh's new book!"

The covers now clearly begin to indicate the UPA style and influence on my work. This juxtaposition of an abstract figure dancing with a disc and a pattern of *Record Changer* want ad text filling his body is similar to the kind of thing we were animating at the studio. Also note the magazine's price leap from 25¢ to 35¢!

The Cat phones Lu Watters with the suggestion that if he really wants to recreate the music of King Oliver's 1923 recordings, he should use the same recording technology!

48

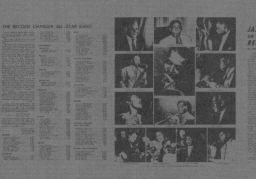

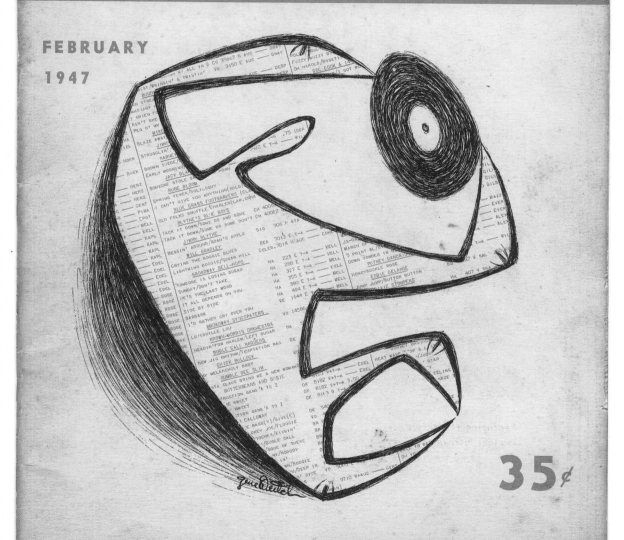

the record changer

FEBRUARY 1947

35¢

A MONTHLY PUBLICATION DEDICATED TO AMERICAN MUSIC

"Hello, Lu? I've got the solution to your last problem!"

I wonder if death threats would make them play real jazz on the radio???

This is one of my favorite covers, not only because it further develops my UPA-influenced graphics, but also because it reflects one of my favorite activities, one that I continue into my old age: the recording of jazz bands. Here you see The Cat (me) pointing his crystal microphone at a New Orleans style band, recording the music onto an acetate disc with one of the first home recorders available on the market. The little scribble you see issuing from the disc is the thread of acetate continuously being dug out of the disc by the sharp recording stylus. From this primitive and uncertain gadget, I upgraded, step-by-step, to a wire recorder, a paper tape recorder, a long series of reel-to-reel tape recorders, progressing to stereo and quadraphonic, to my present shirt-pocket-sized MiniDisc recorder... This too will soon give way to a solid-state recorder, perhaps embedded into my inner ear.

As this was the year 1947, you can take in the joke implied in that month's Cat-toon.

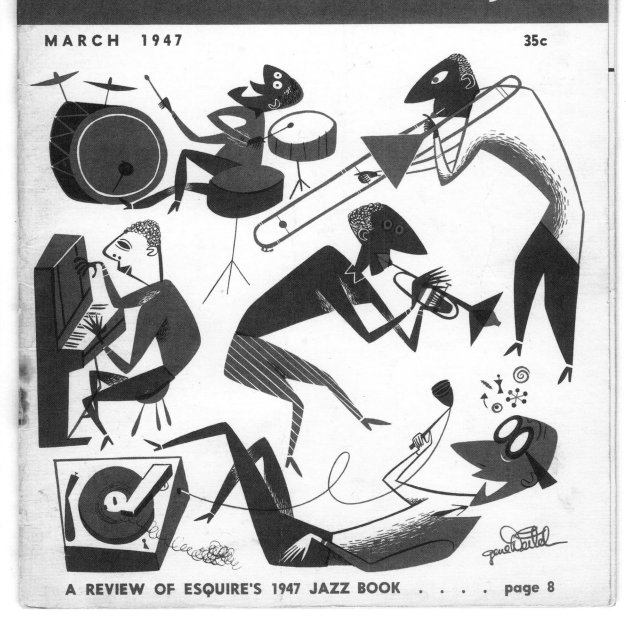

the record changer

MARCH 1947 35c

A REVIEW OF ESQUIRE'S 1947 JAZZ BOOK page 8

"Here's a complete catalog of my records . . . complete up to
June, 1938."

The cover design here reflects the confusion and consternation of collectors suddenly faced with an avalanche of new jazz reissue labels. The design, incorporating hundreds of the new labels, continued onto the back cover! Record company labels were important markers for collectors in those days. We could immediately assess the importance and quality of records by their labels, be they Victor, Columbia, Okeh, Decca, Brunswick, Vocalion, Paramount…. But as the majors failed to supply the fans with enough reissues from their fabled vaults, private buccaneers filled the gaps by simply dubbing new masters from their own privately owned near-mint condition discs and issuing them in limited editions. Today, record buyers rarely even notice the company logos on CDs, but look only for the artist or song titles.

April, 1946's Cat was in the form of a comic strip. It was my growing passion to do a daily and Sunday newspaper comic strip. I finally achieved it with United Feature Syndicate in the mid-1950s, but after only a year I had to choose between that and my animation career.

52

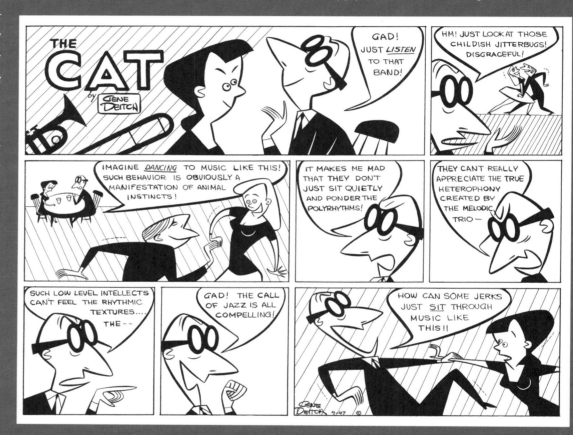

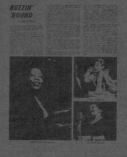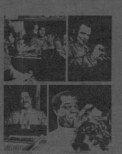

the record changer

APRIL 1947 35c

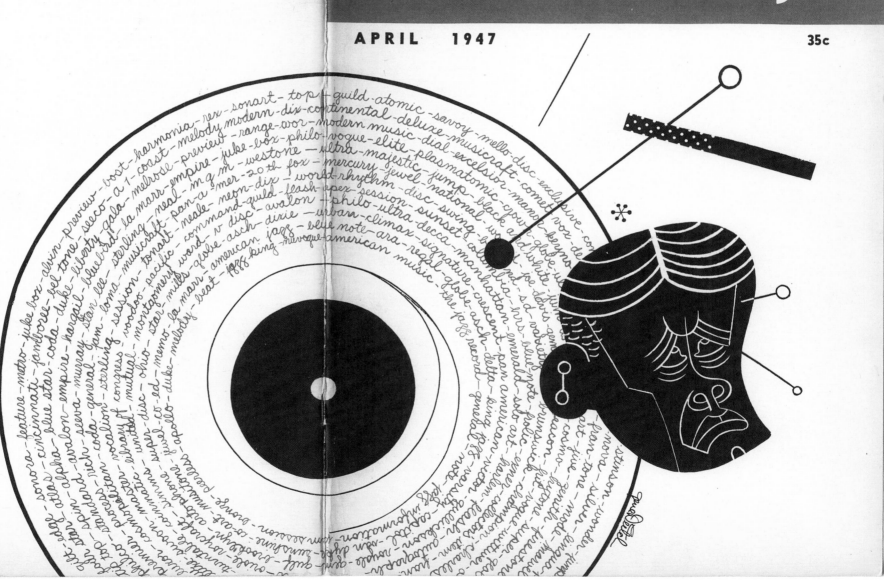

I was experimenting with another borrowed drawing technique in a simple design layout illustrating the features of the magazine.

The Cat illustrates just how boring a one-track, single-subject fanatic can be.

the record changer

RECORDS FOR DISPOSITION

COLLECTORS DISPLAY ADS

CURRENT RECORDS

RECORDS WANTED

MAY 1947

35c

GENE DEITCH

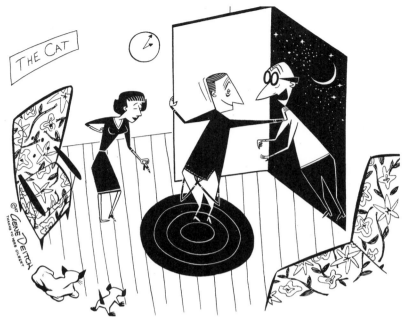

"...AND NOW THAT BRINGS US TO CONSIDER THE SOCIAL AND ECONOMIC ASPECTS OF JAZZ..."

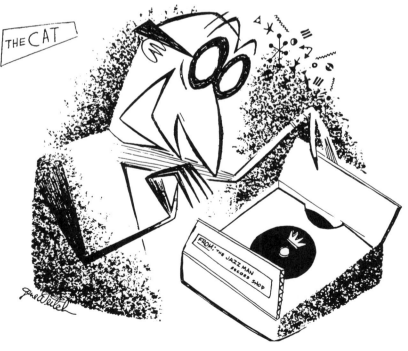

"GAD! AND WITH THE ORIGINAL COBWEBS STILL INTACT!"

The cover shows that having a loud, jazz-playing Cat as an apartment house neighbor is not all that rosy.

A caricature of the real-life ragtime piano man, Johnny Wittwer, modestly deflects The Cat's gushing praise.

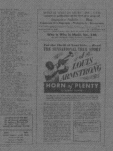

the record changer

JUNE 1947

35c

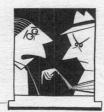
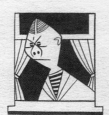
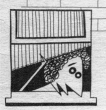
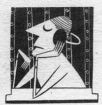
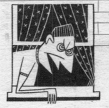
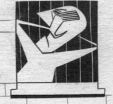
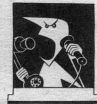
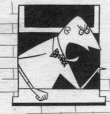
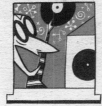
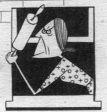
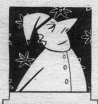
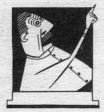
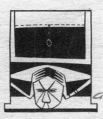

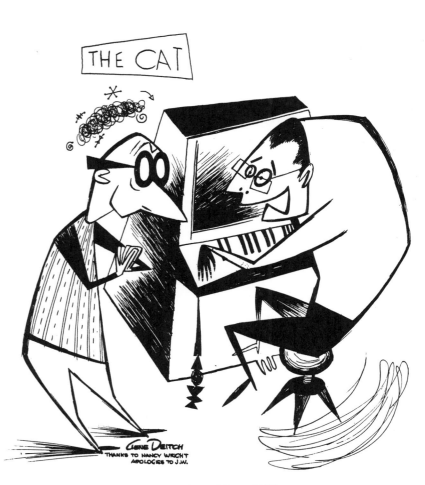

THE CAT

"What?—This old rag!??"

This was my first serious social-statement cover, showing the young white record album buyer riding on a bus, where the actual blues man on the records is forced to sit behind him in the rear "Colored" section.. Nothing subtle about this drawing, but it made its point at the time.

The Cat is showered with catalog cards bursting from the overstuffed drawer containing the data on records no longer loved.

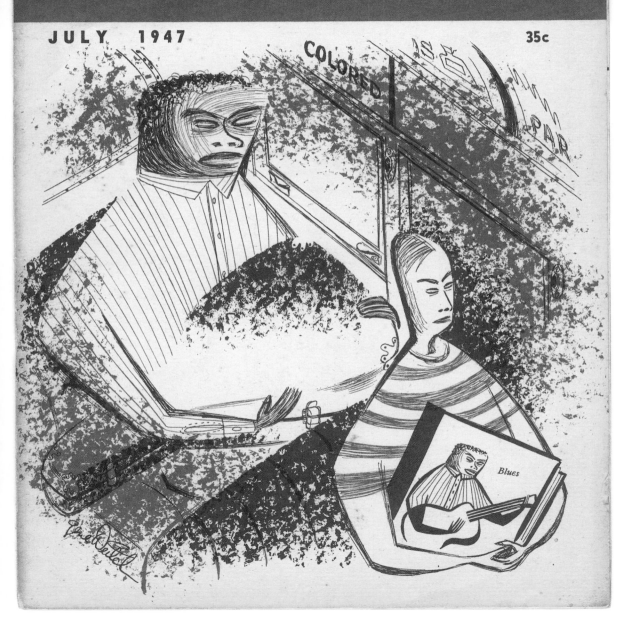

the record changer

JULY 1947 35c

"DAMNED IF THAT DOESN'T HAPPEN EVERY TIME I OPEN THE FILE-
DRAWER MARKED, 'CALIFORNIA RAMBLERS, FOR DISPOSITION!'"

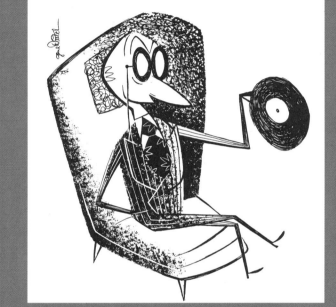

One of the joys of collecting was receiving packages of records in the post. The shower of "plewds & briffits" issuing from the house at the end of the block tells us just who it is that eagerly awaits delivery of that fragile parcel!

My first advertising drawing commissioned by The Jazz Man Record Shop appears in this issue. There is also my drawing of Kid Ory's drummer man, Minor Hall, and lots of my little decorative doodads. There is also one of the "classic" Cat-toons, so they tell me, showing The Cat at an uppercrust dinner party, more interested in the Black waiter than in the glittering guests.

60

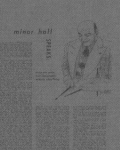
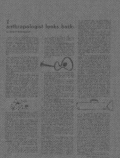
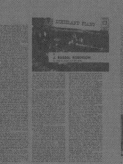
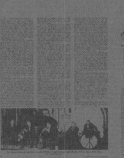

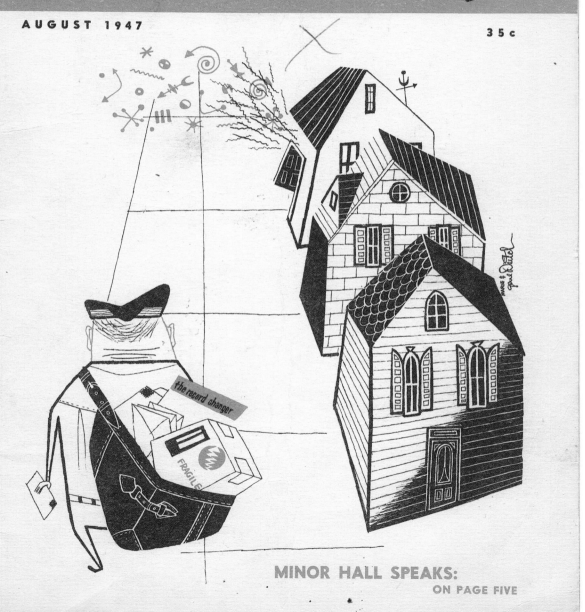

the NEW record changer

AUGUST 1947 35c

MINOR HALL SPEAKS:
ON PAGE FIVE

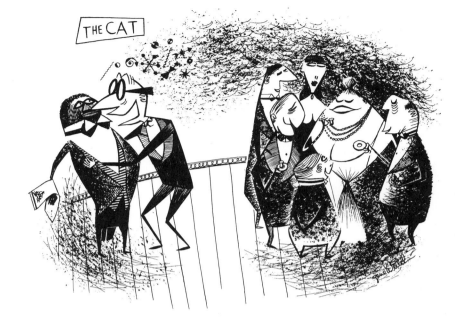

THE CAT

". . . And then what did Tony Jackson say to you?!!"

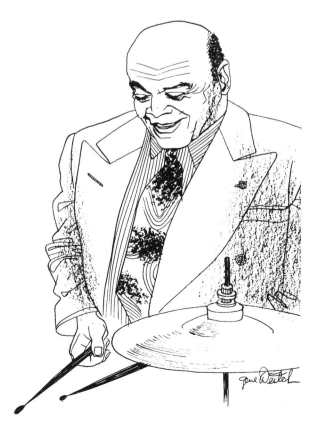

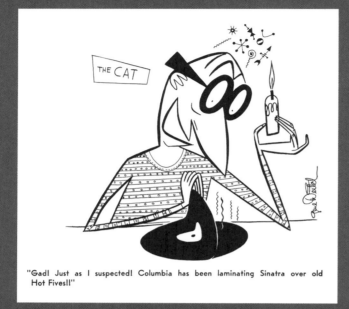

"Gad! Just as I suspected! Columbia has been laminating Sinatra over old Hot Fives!!"

Another anti-segregation statement from me. The progress we take for granted today was still then an unfulfilled hope. Crowds of white dancers fill a hall where a Negro band plays, while a Black couple are fenced out. A simple design about a still agonizing social blight.

Another Jazz Man Record Shop ad drawing by me as well as two more Cat-toons.

One gag, suggested by my friend Spencer Crilly, was about what might have been expected from a Salvation Army band. I found a few rare jazz and blues records in the dusty heaps usually in the back corners of Salvation Army salvage shops, but I seriously doubt that any "Army" folk ever listened to any of them. If they had, the music of the typical Salvation Army bands might have been a lot more surprising!

A war-time shortage of shellac blighted the record industry. Maybe the stuff was derived from Asian beetles. Anyhow, the record shops had to send back old records to be melted down and restamped with the latest releases. We couldn't buy a new record without turning in an old one! Thus many great and rare recordings were lost forever. And of course the recycled shellac made noisy and rough-playing discs. Attempting to solve this, Columbia Records introduced laminated discs. Over a base of the rough stuff they would apply a thin layer of rare, high quality new shellac, thus arriving at a relatively smooth-sounding disc. So my second cartoon for this issue imagined The Cat carefully lifting off a sweet Sinatra song that was layered over a rare 1926 Louis Armstrong Hot Five recording!

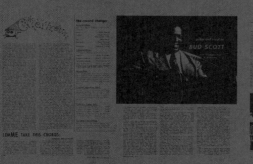
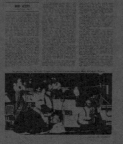
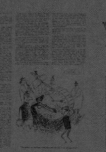

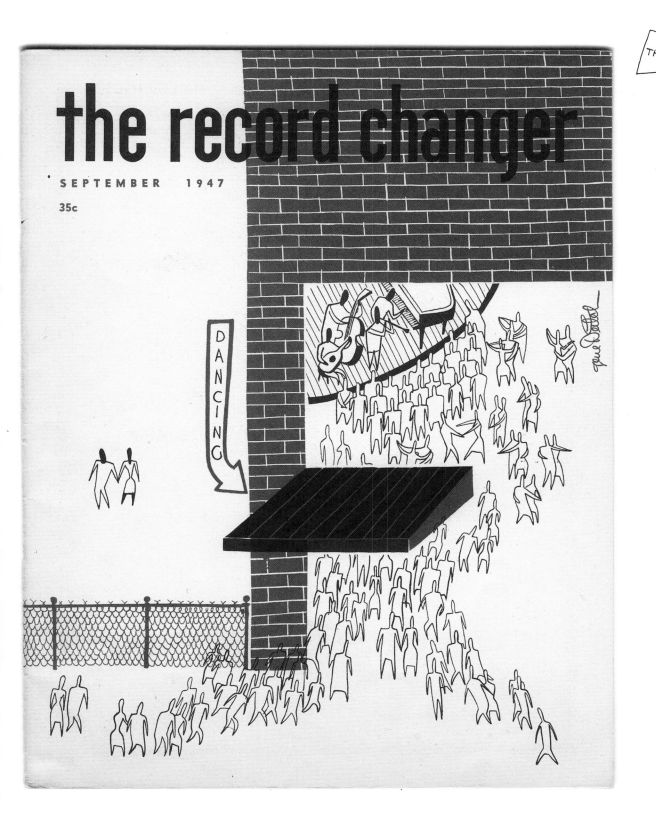

the record changer

SEPTEMBER 1947

35c

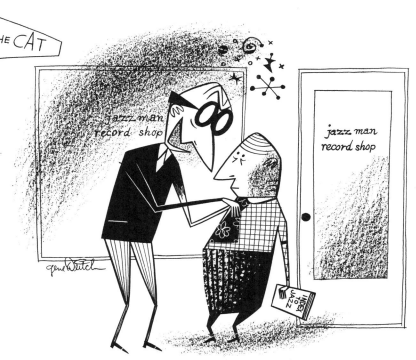

"All right now—straighten your tie, try to look like an old collector, and for heaven's sake don't ask if they have any Tommy Dorsey!"

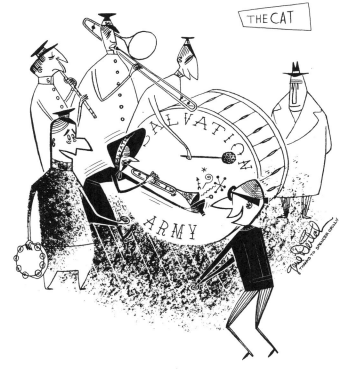

"She picked up that style from some old records in our salvage shop!"

My cover shows the devoted bass player protecting his beloved instrument from the pouring rain by covering it with his own coat and hat. If a musician's livelihood depended on his instrument – often expensive or hard to come by – he did everything possible to keep it from harm.

I've never smoked, but I let The Cat do it just this once to parody tobacco ad terminology of the time, plus a phony southern accent in an ad for The Jazz Man Record Shop.

In the regular Cat-toons in the issue, The Cat is living every collector's fantasy of finding rare jazz records in some old granny's attic. What he's dreaming of is reflected in his glasses. Many classic jazz and blues titles were originally issued on the Okeh record label.

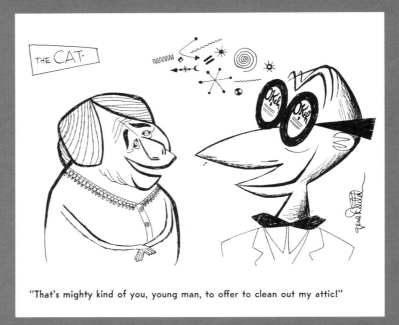

"That's mighty kind of you, young man, to offer to clean out my attic!"

In the second cartoon, we can see that The Cat's first priority, over everything, was to not miss a single broadcast of Rudi Blesh's "This is Jazz" radio program, a delightful rarity on the commercial radio of the day. (TV was still crude and experimental black & white jiggles, only watched by a few who were fascinated that more or less visible pictures were able to be sent through the air!)

64

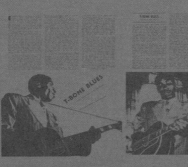
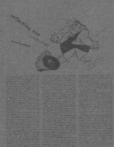

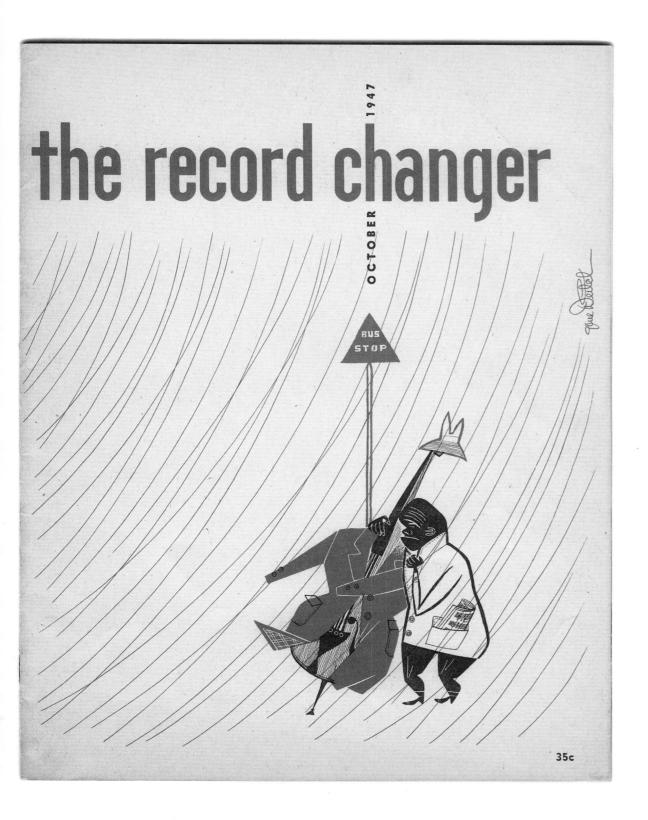

the record changer

OCTOBER 1947

35c

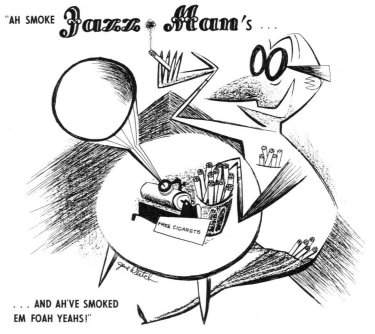

"AH SMOKE *Jazz Man's* ...

... AND AH'VE SMOKED EM FOAH YEAHS!"

AH LIKE THAT FINER, THAT MILDER, THAT NATURALLY AGED ...

JAZZ MAN MUSIC

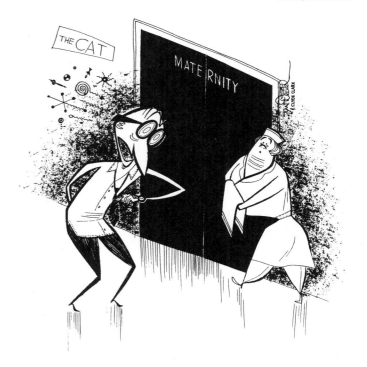

"Good Lord! I've missed *'THIS IS JAZZ.'*"

The one month that year without my cover drawing, but there was yet another Jazz Man Record Shop ad, playing on the same idea as finding a bottle of rare French wine still covered with the dust and cobwebs of a village cellar.

And The Cat discovers King Oliver's actual old cornet made into a table lamp! Such vulgarities did occur, but fortunately never that one.

The second Cat-toon shows him whistling a blues tune to catch a passing maiden's eye. Can any of you who read music tell me what the tune is? I've forgotten!

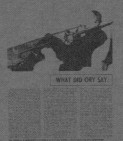

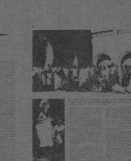
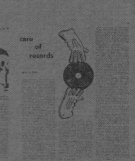

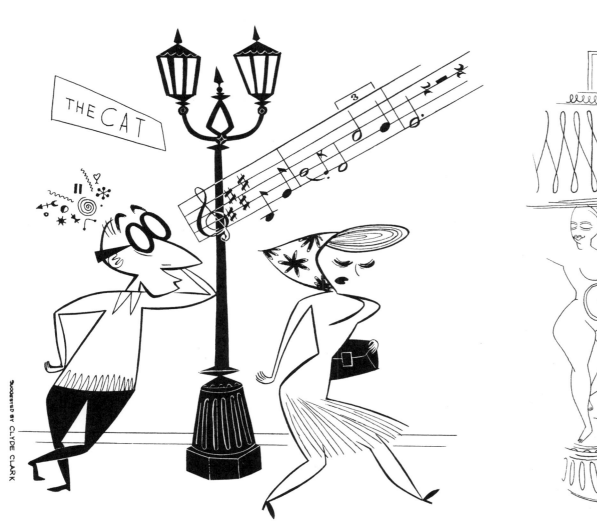

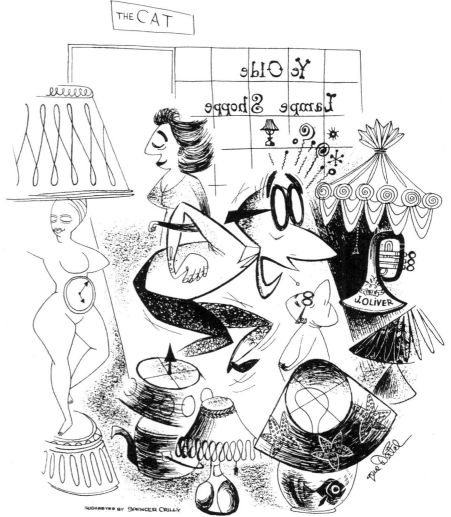

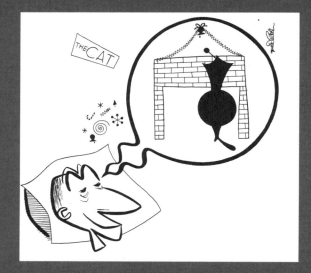

My Christmas cover that year juxtaposes the well-heeled record collector's Yule tree over the image of the fabulous New Orleans clarinetist George Lewis when he was sweating as a longshoreman, loading cotton bales on the Mississippi River docks.

My Jazz Man Record Shop ad that month featured a caricature of shop owner and future record mogul Nesuhi Ertegun, who was then working with me as the magazine's editor at the time…thus explaining the long run of Jazz Man ads during the year!

The Cat again dreams of his favorite stocking stuffer, but has a negative surprise gift coming!

68

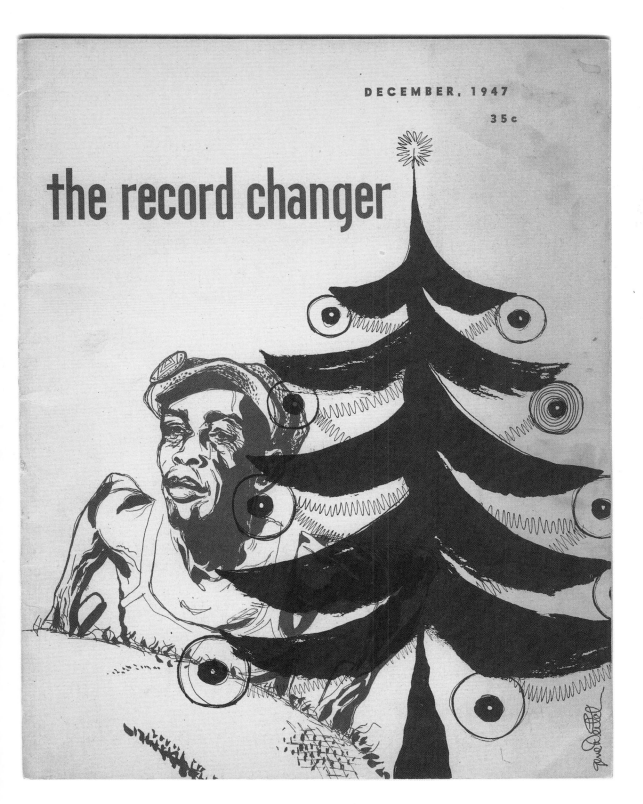

the record changer

DECEMBER, 1947

35c

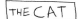

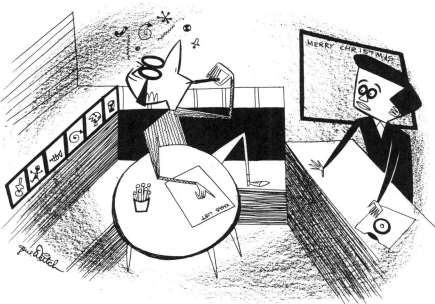

"H'm! Maybe I shouldn't give Sam an original Morton; he only gave me a reissue last Christmas!"

"Yes, dear—I'm sure daddy WILL be surprised with a new shaving mirror!"

1948

This cover was my graphic impression of the death of John Henry, who "died with a hammer in his hand," trying to beat the newly introduced steam drill at driving railroad spikes. Black history embraces this as a true story, and the metaphor carries over until our time, when automation of manufacturing eliminates the need for human labor and thousands of jobs disappear. As a *Record Changer* cover theme, the reference is to the famous Negro work song "John Henry."

Inside, The Cat finds himself in a situation we all experienced: the chance finding of a truly valuable rare jazz record in an ordinary second-hand junk shop, and trying to keep his excitement in check as he bargains for a low price with the proprietor, who he prays knows zip about jazz records!

Also, The Cat is carried away with the perfect traditional jazz expression of love for a woman.

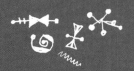

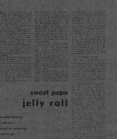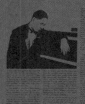

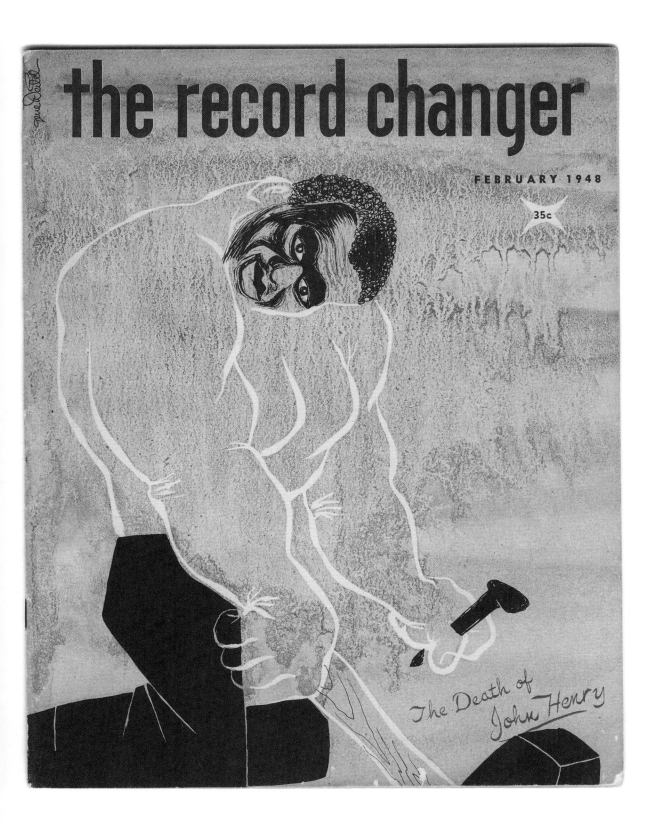

the record changer

FEBRUARY 1948

35c

The Death of John Henry

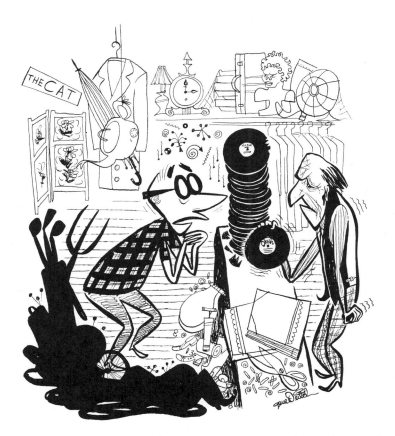

"Well, of course it's pretty old—and scratchy—it can't be worth more than fifteen ce——. *Say!* L-Look out how y-yer holdin' it for heaven's sake!"

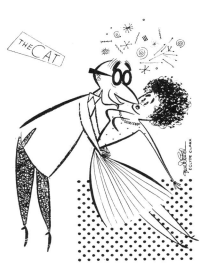

"Gad, Darling! We two could make such beautiful improvised ensemble together!"

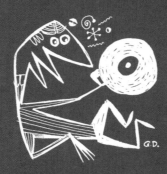

I'm back on the job with a cover experimenting with the style of Saul Steinberg. Here is an apparent rich kid, lounging in the Victorian-style living room decorated by his retro parents. They lurk in the doorway in obvious disapproval of their wayward, jazz-mad son, who is soaking up the Real Thing emanating from the family's ancient wind-up grand gramophone. On the floor is a copy of the February, 1948 *Record Changer* with the John Henry cover!

Now Marili Ertegun (formerly Morden, formerly Stuart) is caricatured in my newest Jazz Man Record Shop ad — and The Cat admires his friend's growing collection.

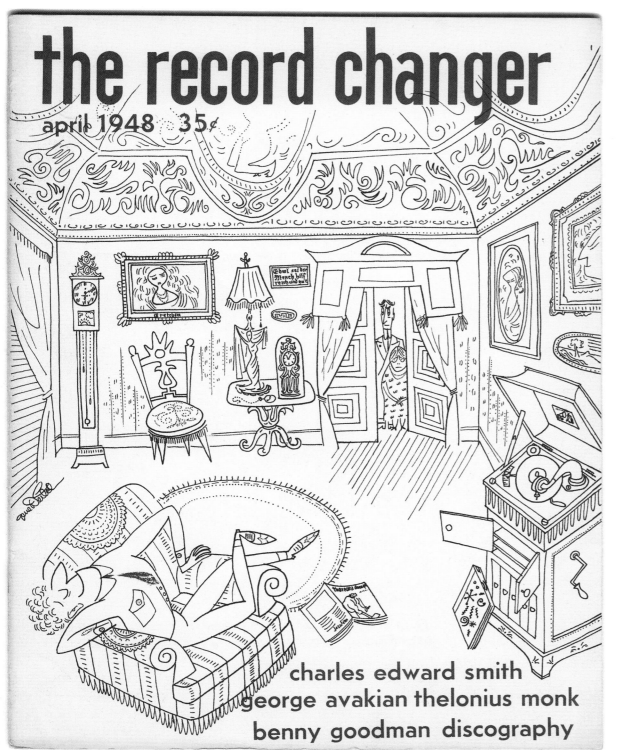

the record changer

april 1948　35¢

charles edward smith
george avakian thelonius monk
benny goodman discography

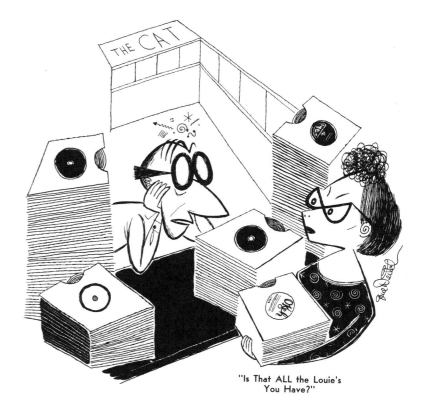

"Is That ALL the Louie's You Have?"

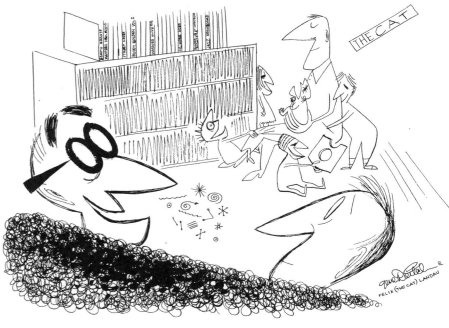

"He's only 23—and just *look* at the size of that collection!!"

This cover is a photographic collage tribute to our royal master, the great King Oliver. The symbolic crown is a cut-out from the *Changer*'s classified auction listings.

The Cat, refusing to believe that Louis Armstrong hit a bad note, disassembles his amplifier, hoping to find the real clinker. Note that the amplifier has glass tubes!!! No such thing yet as transistors, printed circuits, or microchips!

the record changer

may 1948

35¢

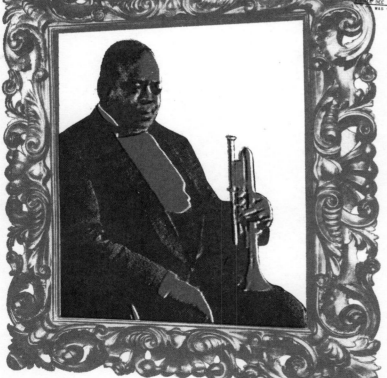

wilber's wildcats — benny carter
eddie condon — george avakian

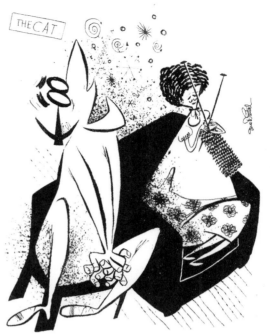

Sometimes, when I get to wondering just what all this means, I play Morton's "The Crave," and everything seems right again!

"It's no use—I'll just have to face it—Louis made a clinker—."

The figure in this cover design was adapted and redrawn from a *National Geographic* photo of an African hunter. As we became more and more aware of the African roots of jazz, this cover idea seemed appropriate.

One of the two Cat-toons inside refers to endlessly seeking lighter and lighter phono tone arms. The second drawing imagines The Cat overhearing another diner in a restaurant ordering the favorite dish of New Orleans jazzmen. That alone is enough to excite his expectations!

78

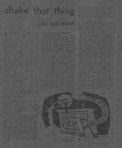

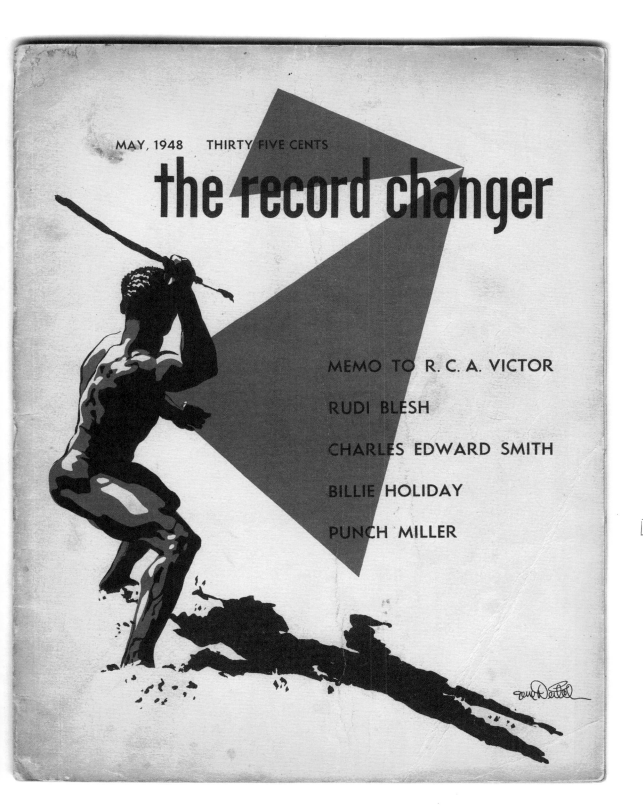

MAY, 1948 THIRTY FIVE CENTS

the record changer

MEMO TO R. C. A. VICTOR

RUDI BLESH

CHARLES EDWARD SMITH

BILLIE HOLIDAY

PUNCH MILLER

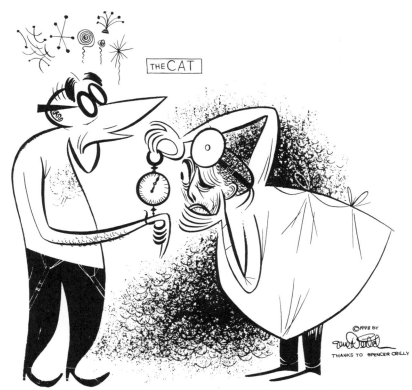

"How Odd—Your Arm Seems to Weigh Only ¾ of an Ounce!"

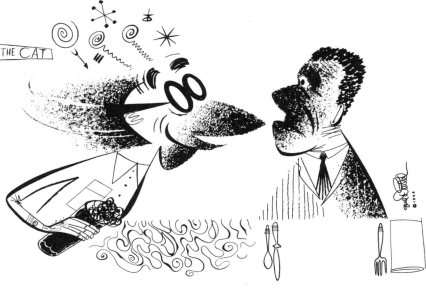

"Pardon me, sir—But did I hear you order red beans and rice?"

This is my personal favorite *RC* cover design; the strong profile of a young Black American, abandoning his southern country acoustic guitar for the dream image of a glowing saxophone! And look what is going on inside his head! This was a transitional period, and whatever we hard-line traditionalists had thought, the music was changing in the setting of the urban North. Whatever, I felt happy with the graphics!

But a Cat drawing inside shows that we were still stuck with having to change needles in our phono tone arms after each and every play. Running out on a Sunday, when the record shops were closed, was a major moaner.

The second Cat-toon was my only truly erotic effort.

80

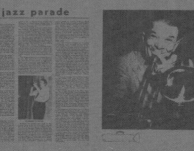
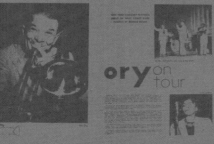

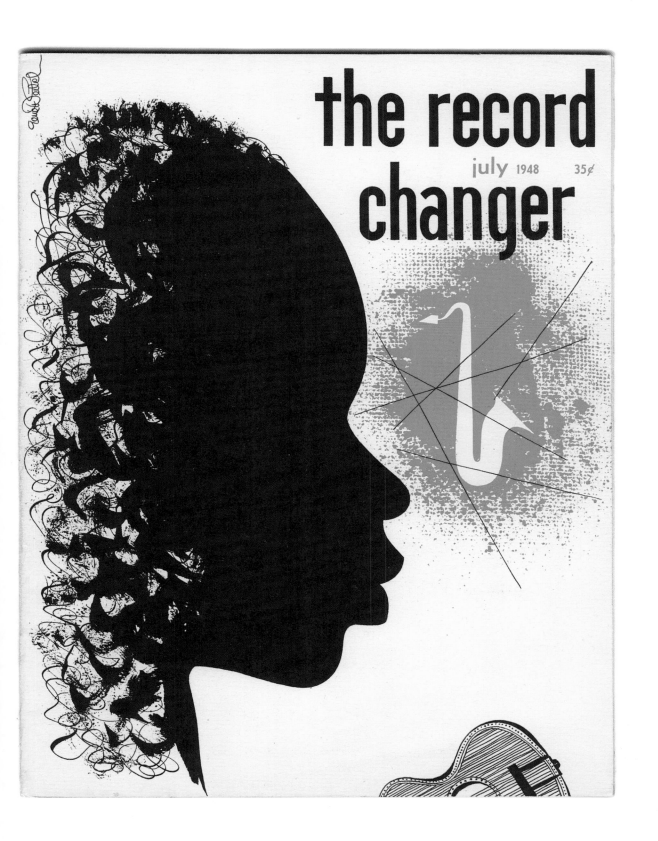

the record changer

july 1948 35¢

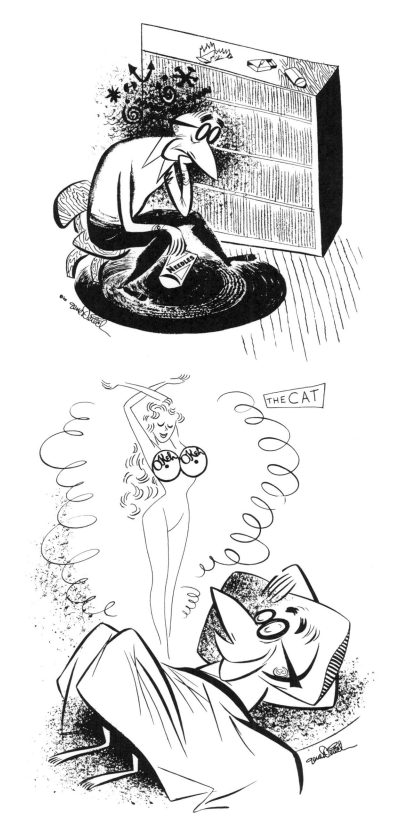

THE CAT

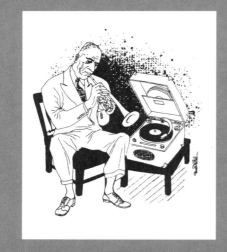

The cover design suggests the unlikely coexistence of a quiet elderly couple and a jazz record maniac within the thin walls of a single boarding house.

The search for a recording by the legendary pioneer New Orleans trumpeter Buddy Bolden has never subsided. In this issue The Cat has actually managed to record him from the Great Beyond, but egad, he's playing a harp instead of a horn!

Also in this issue was another drawing of Papa Mutt Carey, adding his powerful trumpet to a favorite record.

82

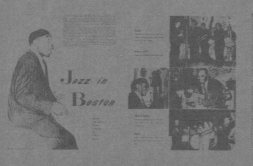

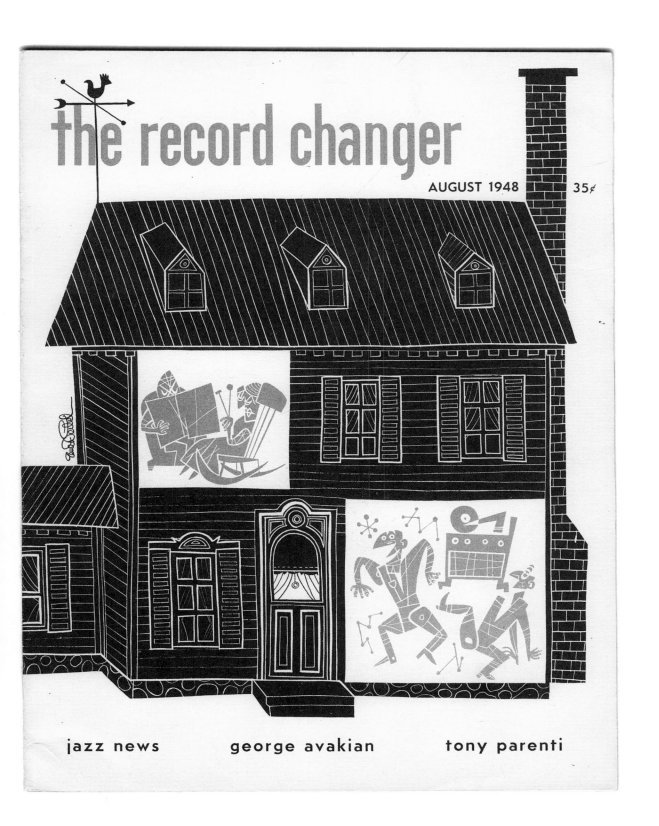

the record changer

AUGUST 1948 35¢

jazz news george avakian tony parenti

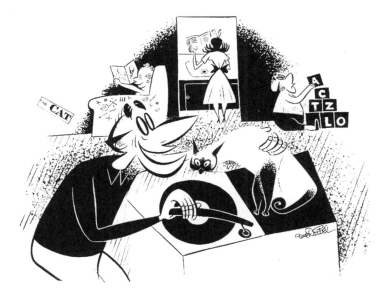

"Now dig the second ensemble chorus, right after the washboard break!"

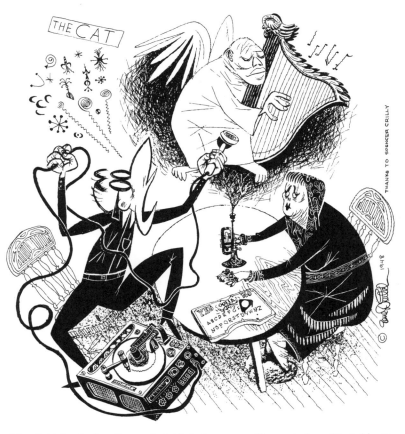

"Egad! He's playing Blues, all right, but no one will ever believe it's Bolden!"

84

I once rode in a New York taxi with a Black driver who had a trumpet on his lap. At every stop light or bit of traffic gridlock, he lifted the horn to his lips, and sounded out a chorus of the blues! And a similar real-life New York sighting inspired this month's cover drawing. This shoe shiner was just trying to make a living while waiting for that great gig.

The Cat gag in this issue was wacko, but entirely possible. Some commercial bands tried every which-a-way to get a unique sound. Shep Fields not only had an all-saxophone orchestra, but earlier even had one player blowing bubbles through a straw in a glass of water, so an all-drum band was not entirely out of the question… and hey, look at the present success of the recent "Stomp!" group.

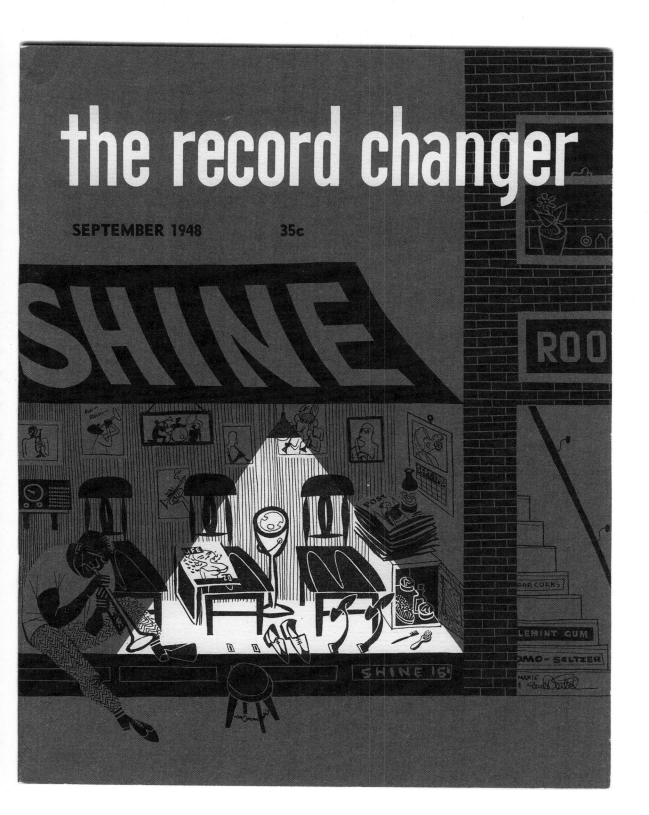

the record changer

SEPTEMBER 1948 35c

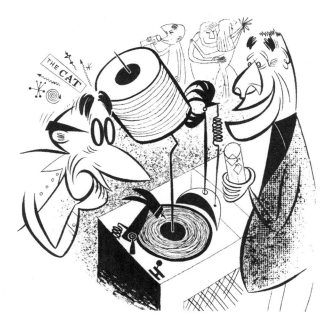

"Don't be so impatient—the records you brought are coming up next!"

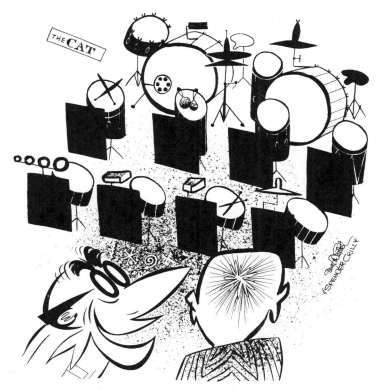

"I Understand This Band Has a Fine Beat"

This cover is another take on the endless problem of filing systems for large record collections. Tucked under the image of the typical cardboard record sleeve is a file card asking the question of how one would file a 78RPM single with one band on the A side and another band on the B side.

Inside, The Cat wants to order a custom-built instrument case. His instrument is an ordinary, old fashioned washboard, usually played with sewing thimbles. This gag idea was suggested on a postcard from Arthur Schawlow, who I found out much later was Professor Arthur Schawlow, who won the Nobel Prize for inventing the laser! If you don't believe me, look him up in *Who's Who!* We eventually became close friends and buddy record shoppers. He also loved to record local bands, either near his Stanford University lab or on his extensive lecture travels. He seemed to have more interest in jazz than in physics, and tossed his Nobel medal in a drawer under a jumble of jazz CDs.

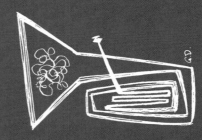

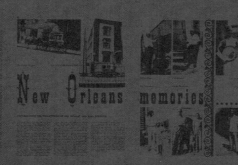

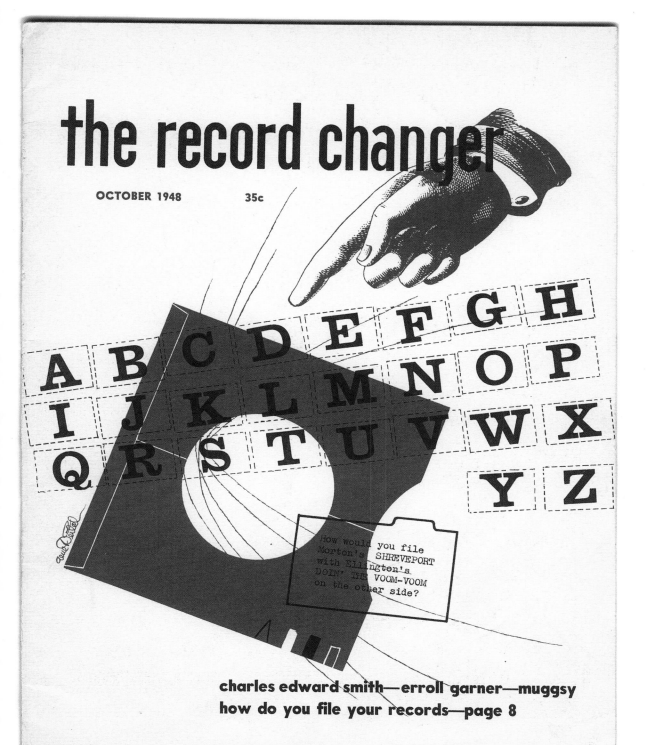

the record changer

OCTOBER 1948 35c

A B C D E F G H I J K L M N O P Q R S T U V W X Y Z

How would you file Morton's SHREVEPORT with Ellington's DOIN' THE VOOM-VOOM on the other side?

**charles edward smith—erroll garner—muggsy
how do you file your records—page 8**

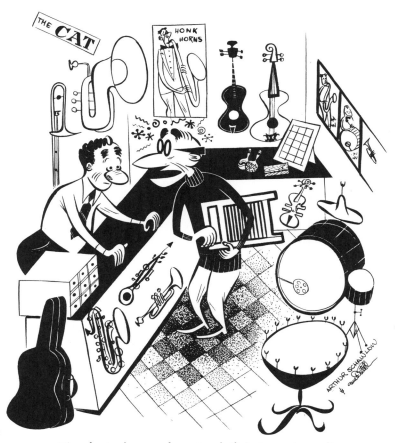

"I understand you make custom-built instrument cases!"

This cover design was either my impression of a New Orleans whore, or a mean blues belter – I can't remember which. Anyway, I had fun drawing it. It may have been inspired by a fragment of a photo I saw somewhere…?

This issue of the magazine mourned the death of Mutt Carey, and my portrait of him was run again. There is also my new drawing of a New Orleans marching band trumpeter, and The Cat trying to put the best spin on some beat-up discs he's trying to unload.

Also, this issue ran the first of a special series I worked up, trying to find some more fun in the foibles of various jazz collectors and their collections. The first installment was called "LISTENERS."

88

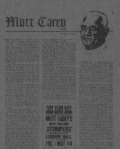

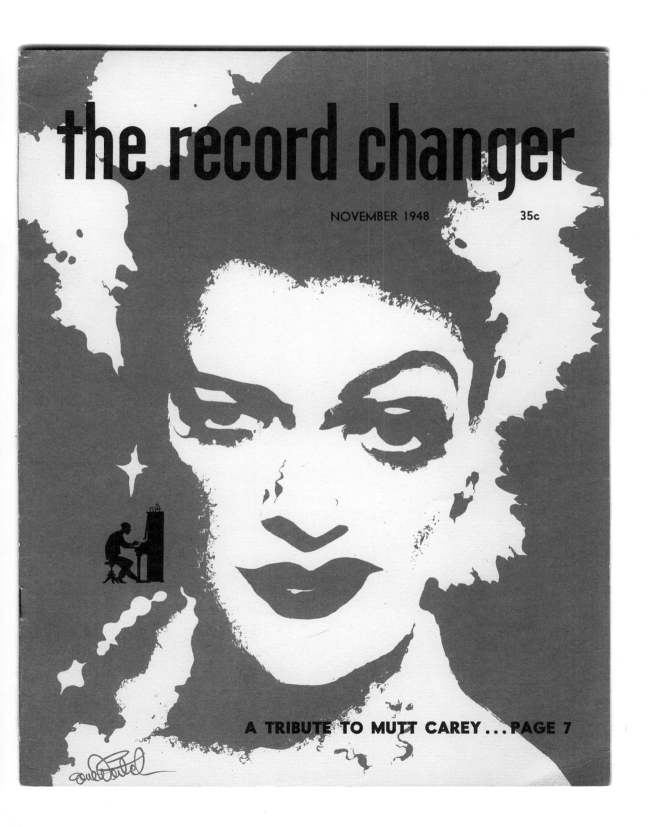

the record changer

NOVEMBER 1948 35c

A TRIBUTE TO MUTT CAREY ... PAGE 7

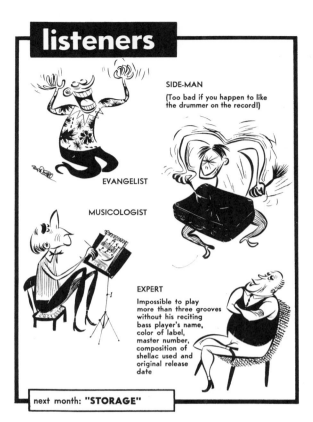

listeners

EVANGELIST

MUSICOLOGIST

SIDE-MAN

(Too bad if you happen to like the drummer on the record!)

EXPERT

Impossible to play more than three grooves without his reciting bass player's name, color of label, master number, composition of shellac used and original release date

next month: "STORAGE"

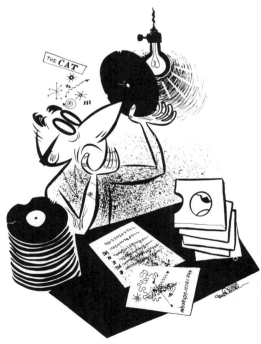

"Hm—I'd say this one is at least 'excellent,'—it's got only one hole in it."

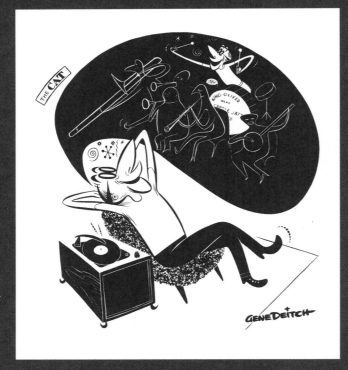

The December '48 cover drawing was based on a real incident. At one of our Friday night record sessions, one of the guys present told us of an aging New Orleans trumpeter who had lost his teeth and could no longer play. Worse, he and his wife were too poor even to buy a record player. The guy couldn't even play his own records. So some fans chipped in to buy a simple player and shipped it to him in time for Christmas. I thought that was a great thing, and made this symbolic drawing to commemorate this kindness.

Probably every cat dreams of being a sideman in his favorite band, and my Cat was no exception. He also dreams once again of his Christmas stocking stuffed with a disc.

Various people have used and reprinted my drawing of Jelly Roll Morton. I was very surprised and gratified when I came across a 12-LP Swedish edition of Morton's Library of Congress recordings that had this very drawing of mine on the cover of all 12 LP volumes!

Also in this issue was the "STORAGE" installment of my special series.

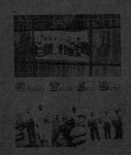

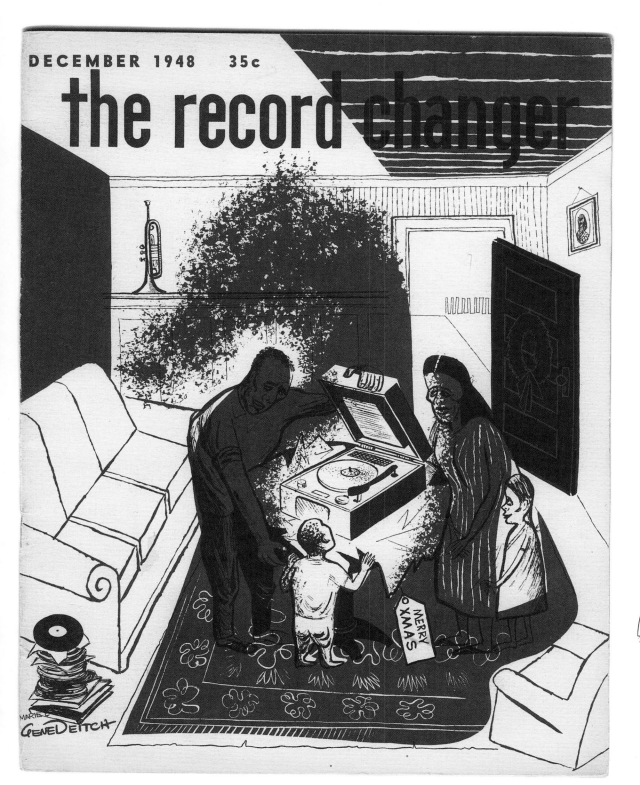

DECEMBER 1948 35c

the record changer

storage

Old Man's a Cabinet-maker

Label-Fiend

Apple Box Special

Accessible

His Wife Tells Friends They're a Set of Encyclopedias

Small Brother-Proof

next month: " SHIPPING "

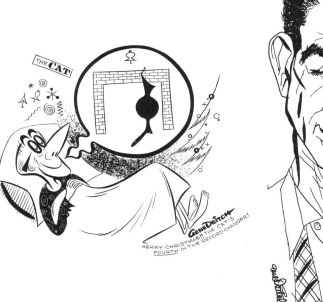

THE CAT

MERRY CHRISTMAS!! THE CAT'S
FOURTH IN THE RECORD CHANGER!

1949

We once went to a jazz concert featuring Louis Armstrong's All Stars held in a giant sports stadium in Los Angeles, and from where we sat the band was just a vague group of miniature figures, barely visible from a great distance, more or less like in this cover drawing.

The first collection of Cat drawings up to that time was issued in a little $1.00 booklet with commentary by the famous jazz writer and record producer George Avakian. By this time, *The Record Changer* had moved to New York, now published by Bill Grauer. Orrin Keepnews was then the Managing Editor.

The third in my special series was in this issue, titled "EQUIPMENT," and the Cat-toon imagined the alarm it could cause in the house if The Cat would stop playing his records, drums, and tuba full blast.

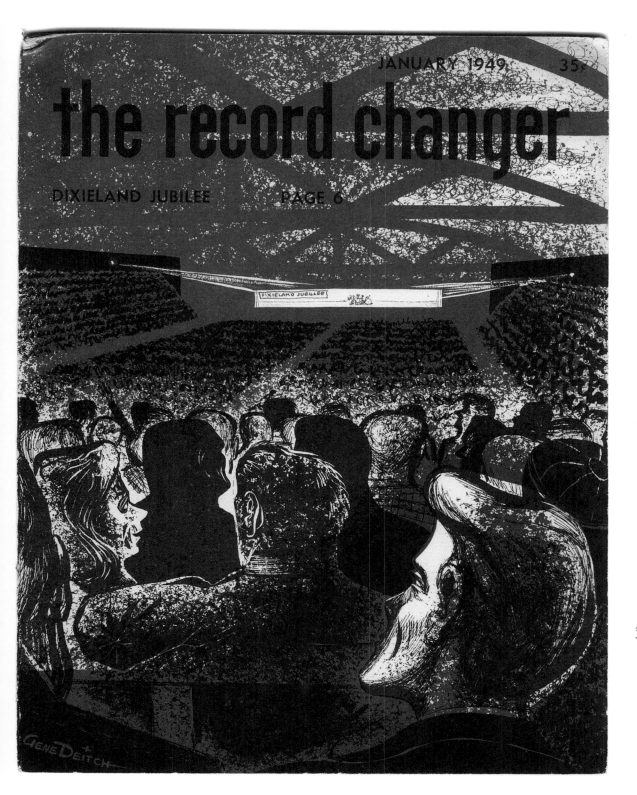

the record changer

JANUARY 1949 35¢

DIXIELAND JUBILEE PAGE 6

equipment

Old School

Modest

Home Craft

Custom Built
Hi-Fidelity

next month: "TECHNICAL EXPERTS"

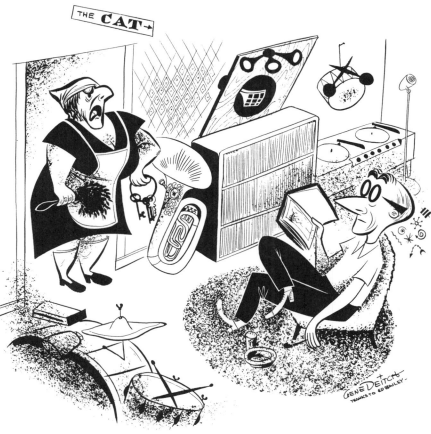

THE CAT →

"The Other Tenants are Complaining About the Silence"

I suppose the title of this cover might be "The Birth of The Blues," and you can see from what the stork is carrying that the baby looks exactly like its dad!

Another in my record fanatics series appears in this issue of *The Record Changer*. This one is on the "Technical Experts," those who struggled every which-a-way to derive the maximum semi-pure sound out of those primitive 78RPM discs by way of ever lighter pick-up arms (this guy is going so far as to suspend the naked needle from a thread!), the cactus needle agriculturist, the 64 tube amplifier-equalizer (for the moneyed collectors), and the disc surgeon and groove shampooer, ready to try any of the many worthless nostrums the record shops were selling in those days. The joke is that even today, with CDs, which in my opinion should be left in peace, the CD cleaners and buffers are still being hawked.

The Cat-toon in this issue records the humiliations that a jazz purist had to endure in attempting to make it with a potential lay. In case any of you draw a blank on this one, the nasal-voiced Vaughn Monroe and his orchestra were, as they used to say, "as square as a bear."

FEBRUARY 1949 35c

the record changer

jazz news

bebop

george avakian

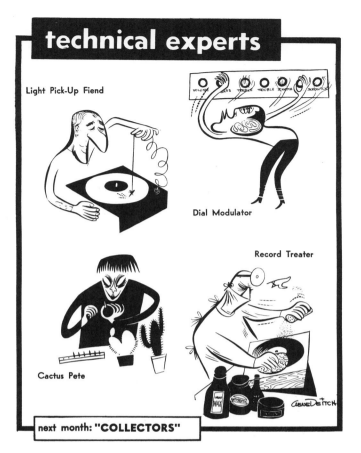

technical experts

Light Pick-Up Fiend

Dial Modulator

Record Treater

Cactus Pete

next month: "COLLECTORS"

"Every time you play me that Vaughn Monroe record, I realize how much we have in common."

The cover showed that even with the most careful cataloging it was still mainly guess work to find the record you were looking for.

The mini-series continued with "COLLECTORS," each one sillier than the other. But there was one almost prophetic collector, with his entire collection on a spool of tape. Today we can almost do that with proper compression on an MP3 device.

I did an advertising drawing for another great jazz disc source, The Record Shack.

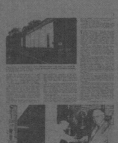

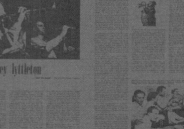

the record changer

MARCH 1949 35c

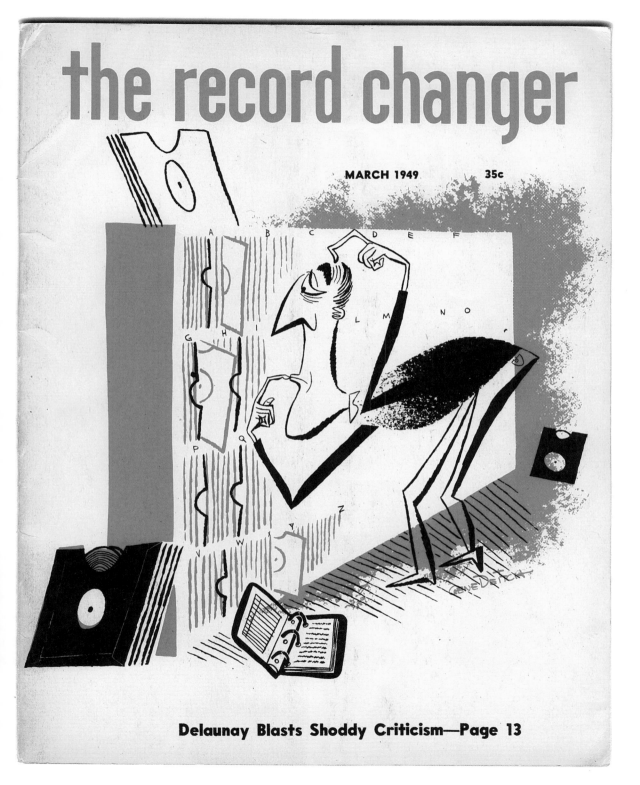

Delaunay Blasts Shoddy Criticism—Page 13

"Ya know, Al, I think we'd better stack the next batch of records in _that_ end!"

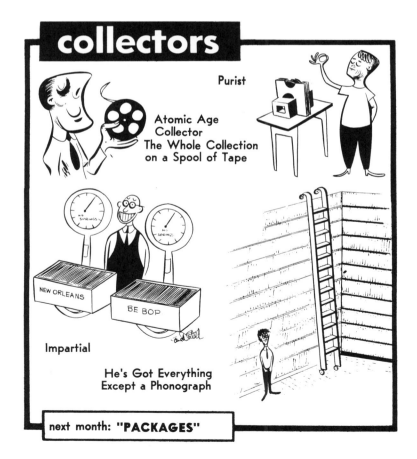

collectors

Purist

Atomic Age Collector
The Whole Collection on a Spool of Tape

Impartial

He's Got Everything Except a Phonograph

NEW ORLEANS

BE BOP

next month: "PACKAGES"

Even high-toned musicologists began to take "Afro-American Music" seriously. My cover that month caricatured just such a type.

The Cat himself was now a musicologist lecturer, although sometimes slipping into the vernacular.

There was also a simple drawing of the young Louis Armstrong, and the last of my mini-series, "PACKAGES." It referred to the main way that the buying, selling, and trading of records through the classified ad pages of *The Record Changer* was really accomplished. It was by the good ol' U.S. Mail. How to manage this in practice, with reasonable hope that the brittle shellac records would actually survive our notorious postal system and arrive unbroken, required great skill in packaging. This panel examined some of the less successful attempts at challenging the mailman.

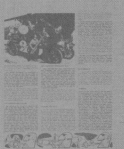

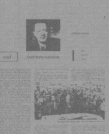
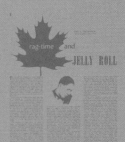

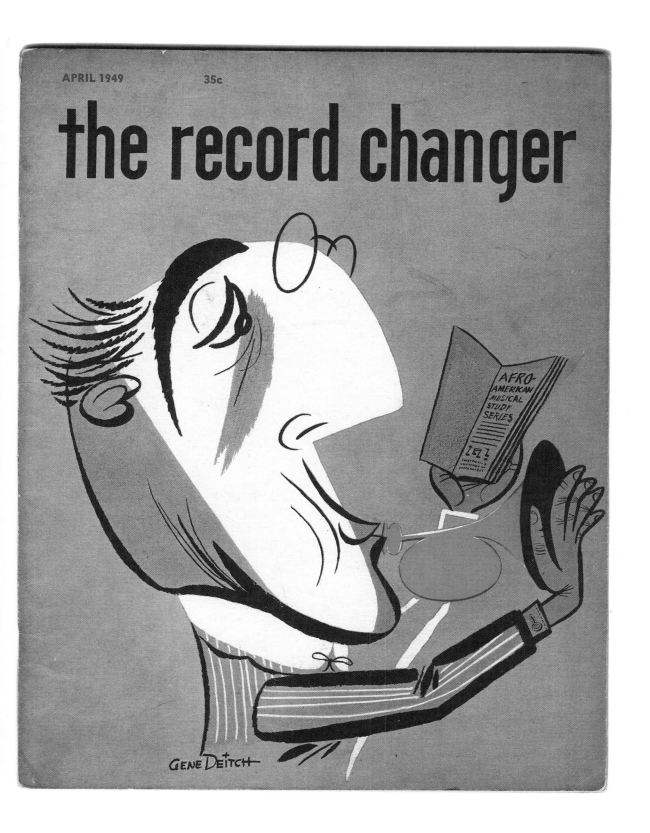

APRIL 1949 35c

the record changer

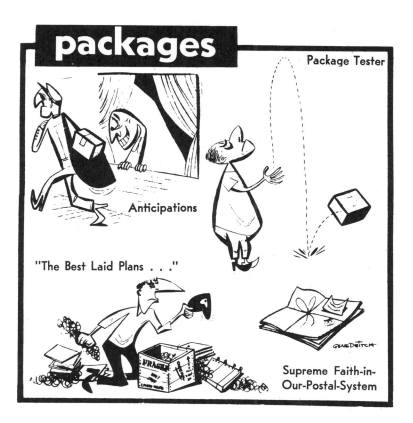

packages

Package Tester

Anticipations

"The Best Laid Plans . . ."

Supreme Faith-in-Our-Postal-System

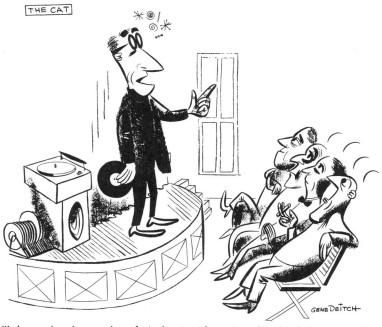

THE CAT

"I have played examples of Authentic Aframerican Vocalized Instrumentation, Polyphonic Improvisation, Dissonant Harmony as expressed in river chants, undulating pitch of street cries, and the complex church rhythms which led to the development of jazz. Now this next record is really a bitch. . . ."

Here on the cover, a young acolyte is properly humble in the presence of an actual player on the record he so tenderly holds in his hands. How many of us dreamed of such a visit? And how few of us ever lived it? My greatest visit was from John Lee Hooker in Detroit, 1949, just a couple of months after I drew this cover!

Inside was another ad for the Record Shack, and The Cat is driven to psychic distraction by visions of the embodied threat to traditional jazz purity.

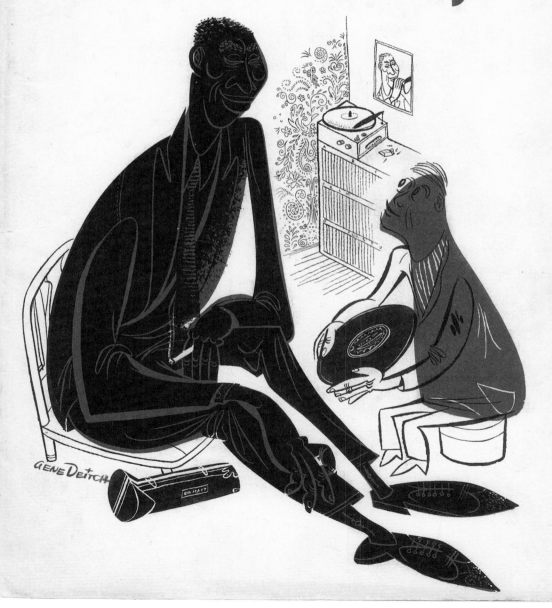

the record changer

MAY, 1949 35¢

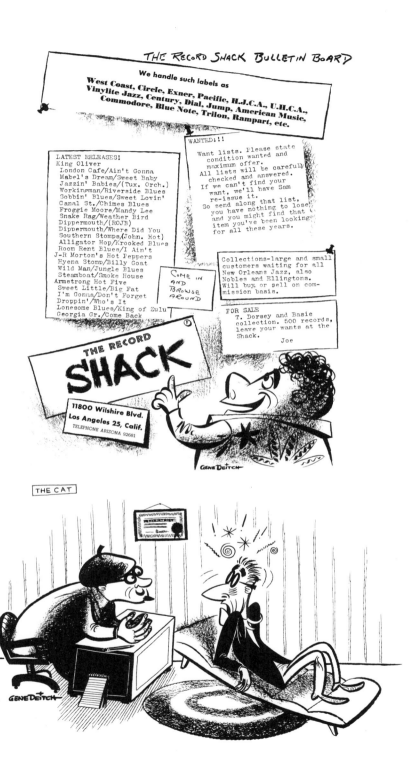

THE RECORD SHACK BULLETIN BOARD

We handle such labels as

West Coast, Circle, Exner, Pacific, H.J.C.A., U.H.C.A., Vinylite Jazz, Century, Dial, Jump, American Music, Commodore, Blue Note, Trilon, Rampart, etc.

LATEST RELEASES!
King Oliver
 London Cafe/Ain't Gonna
 Mabel's Dream/Sweet Baby
 Jazzin' Babies/(Tux. Orch.)
 Workingman/Riverside Blues
 Sobbin' Blues/Sweet Lovin'
 Canal St./Chimes Blues
 Froggie Moore/Mandy Lee
 Snake Rag/Weather Bird
 Dippermouth/(ROJB)
 Dippermouth/Where Did You
 Southern Stomp/(John. Hot)
 Alligator Hop/Krooked Blues
 Room Rent Blues/I Ain't
J-R Morton's Hot Peppers
 Hyena Stomp/Billy Goat
 Wild Man/Jungle Blues
 Steamboat/Smoke House
Armstrong Hot Five
 Sweet Little/Big Fat
 I'm Gonna/Don't Forget
 Droppin'/Who's It
 Lonesome Blues/King of Zulu
 Georgia Gr./Come Back

COME IN AND BROWSE AROUND

WANTED!!!
Want lists. Please state
condition wanted and
maximum offer.
All lists will be carefully
checked and answered.
If we can't find your
want, we'll have Sam
re-issue it.
So send along that list,
you have nothing to lose
and you might find that
item you've been looking
for all these years.

Collections-large and small
customers waiting for all
New Orleans Jazz, also
Nobles and Ellingtons.
Will buy or sell on com-
mission basis.

FOR SALE
T. Dorsey and Basie
collection. 500 records,
leave your wants at the
Shack.
 Joe

THE RECORD
SHACK

11800 Wilshire Blvd.
Los Angeles 25, Calif.
TELEPHONE ARIZONA 92681

GENE DEITCH

THE CAT

GENE DEITCH

"Now try to relax and tell me just when it was that you first began to notice that everyone looked like this Mr. Gillespie?"

This was another of my favorite covers, inspired by a photograph by Ed Shaughnessy, because it was a drawing of one of my favorite musicians, Kid Ory, and because I knew him personally. His way of playing the trombone was the right way according to my purist opinion at that time. Of course, I still think he was great, but as I had The Cat say in one of my later cartoons, "My tastes have since broadened. I once thought the style up to 1926 was my acceptable limit. I can now listen to some things of a later time, say 1938."

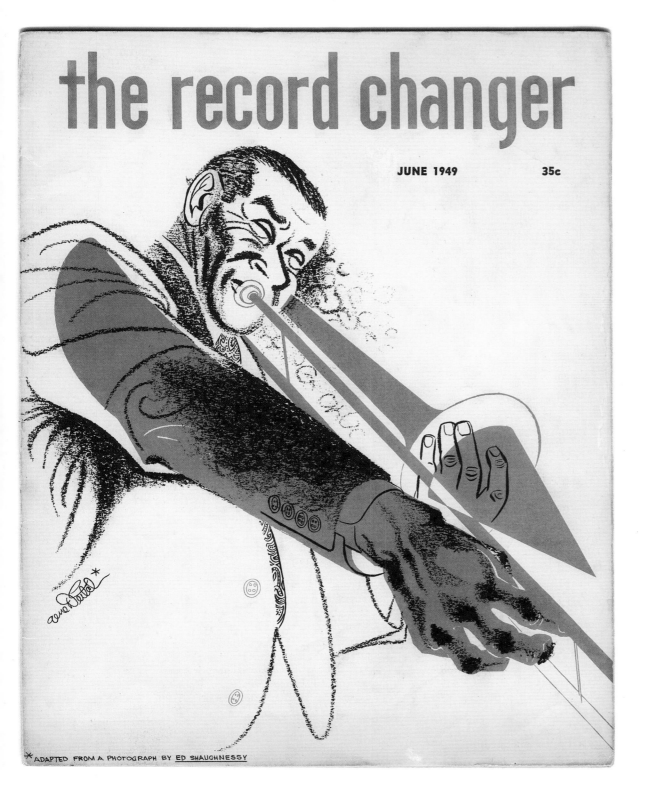

the record changer

JUNE 1949 35c

*ADAPTED FROM A PHOTOGRAPH BY ED SHAUGHNESSY

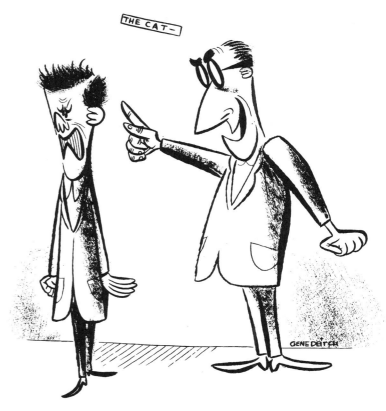

THE CAT—

"Aha! So you admit you've never heard the band either! So how can you contradict my opinion?"

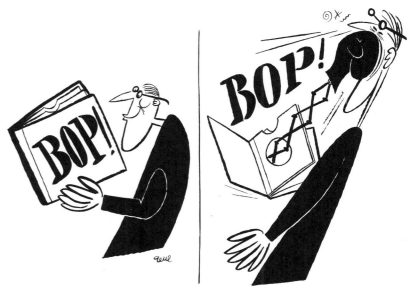

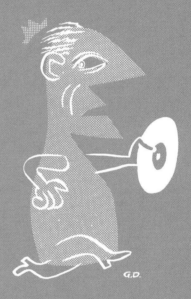

Earlier that year I moved from Hollywood to Detroit, to take up an offer from a commercial film studio there that would give me a chance to become a director. My cover for July was inspired by the hazards of moving the most precious commodity of all. OK, I had two kids, but I let my wife arrange their things for the moving, and the moving men could do what they wanted with our furniture. But I didn't let them touch my record collection! I schlepped every box full of discs myself, and carefully placed them in the safest positions. I was proud that my entire collection arrived in Detroit unscathed.

The Cat idiotically commits the cardinal sin, bringing home a jazz player his wife is sure to hate.

Otherwise, in another drawing, he has found at least half of one of the most valuable of all recordings. The other half must surely be somewhere in that Salvation Army heap, and what matter if he would not actually be able to play it? Possession is what mattered!

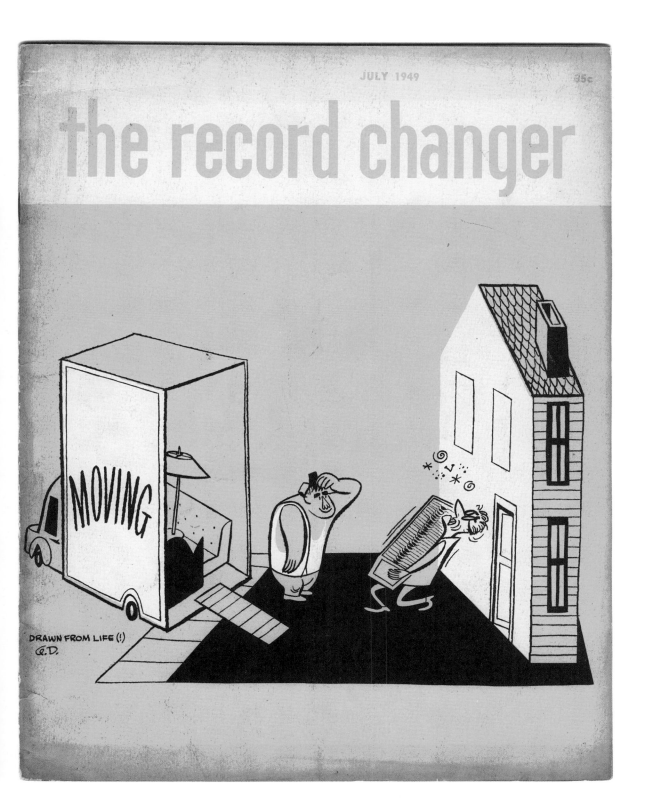

JULY 1949 35c

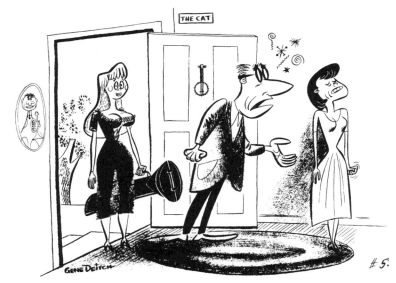

"But, dear—how can you say you don't like her, when you haven't even heard her!"

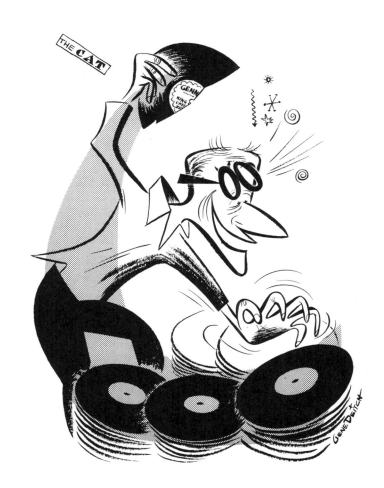

A day at the beach! Sun, sand, the ocean, surrounded by a bevy of barely clad chicks. But is The Cat truly there? He goes nowhere without a box of his favorite records and a portable player. That's where he is coming from and going to at all times.

This may be the best Cat-toon of all. It says everything I ever wanted to say about this character. What is a mere soul in comparison to a 100% complete jazz record collection? Spencer Crilly, wherever you are, I thank you for suggesting this gag!

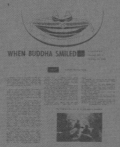
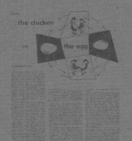

the record changer

AUGUST 1949 35c

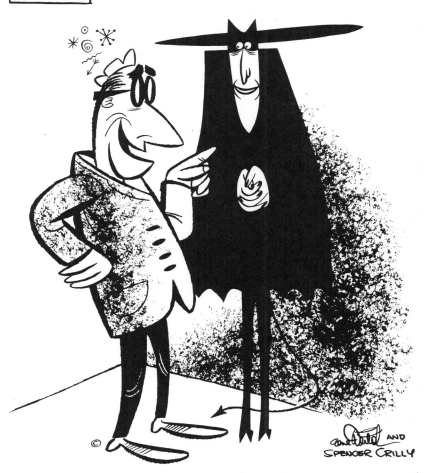

THE "CAT" AT THE BEACH

THE CAT

"Now let me get this deal straight: you say you can get me every record I ever asked for. . . . Surely you must want *something* from me!?!"

No cover drawing of mine on that month's cover, but the September, 1949 Cat indicates the intense emotional involvement a true blues lover had with his records.

 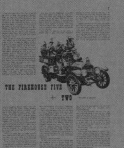 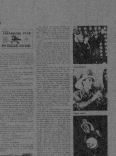 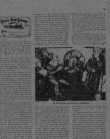 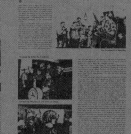

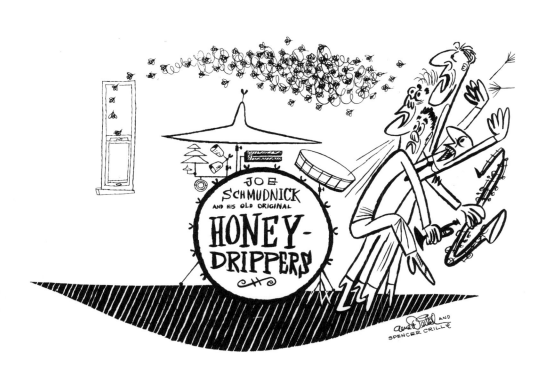

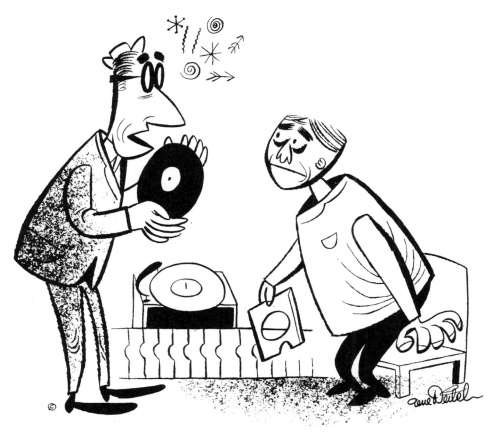

THE CAT

"You'd better sit down; the first time I heard this side I fainted!"

This cover is a sort of stage set design for a play set in a New Orleans bawdy house.

The Cat makes it clear that beauty exists only in the eye of the beholder.

 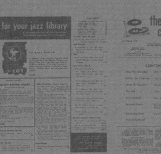 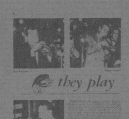 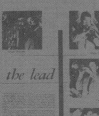

the record changer

OCTOBER 1949 35c

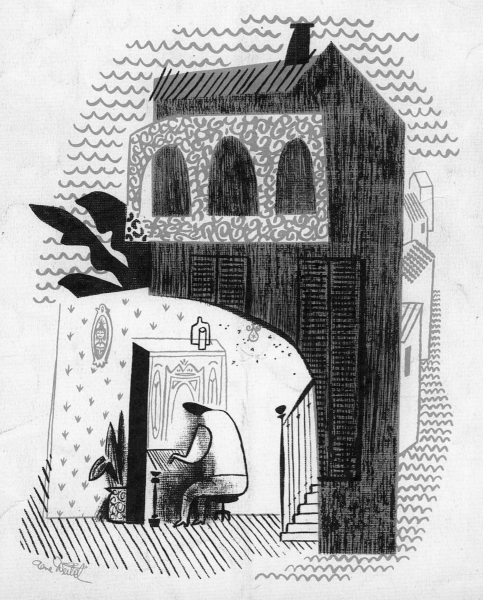

THE CAT

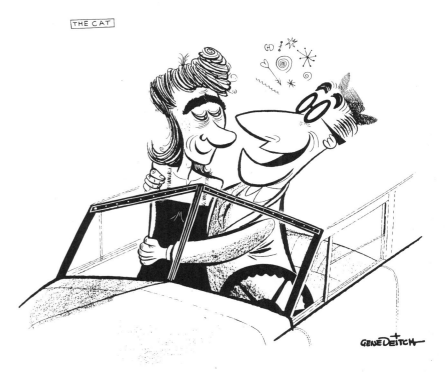

"Gad, baby—I've always had such lousy luck on blind dates—you're the first one that's ever been a Keppard collector!"

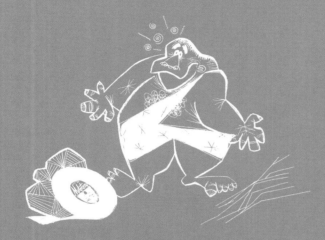

I portray another jazz concert, this one outdoors, on this cover. Today, this kind of audience excitement only seems possible at a rock concert. I weep!

Always ready to embrace new technology in the preservation of music, The Cat endorses the new 45RPM discs, with the hole in the center big enough for his nose to pass through.

The new 45RPM player, put out by RCA, with the thick spindles, is on a stand in front of him. They didn't ever make it on the market, and soon a ridiculous compromise had to be made: the little plastic insert that restored the old standard record hole, in order to accommodate 45s to the soon-introduced 3-speed record players. So 45RPM records were always an anomaly and thus doomed from the start. Classical 45s never made it at all. The Columbia Records LP and the 33.3RPM speed became the new standard for many years, until nudged aside by CDs which have no fixed speed at all!

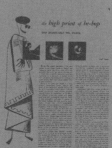

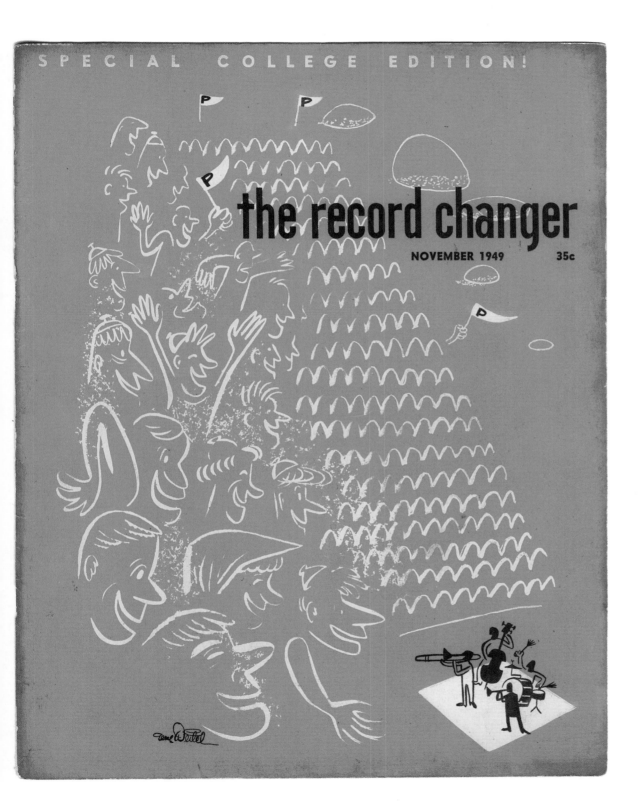

SPECIAL COLLEGE EDITION!

the record changer

NOVEMBER 1949 35c

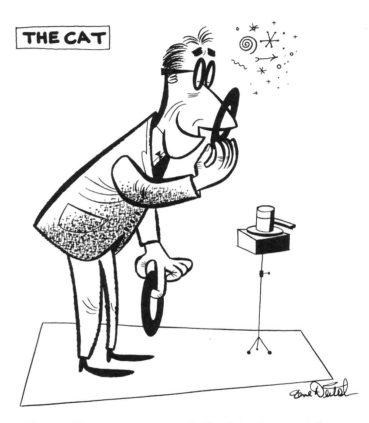

THE CAT

The new 45RPM records are great for The Cat, as he can get them close enough to his eyes to read the fine print on the labels!

Among the gifts under the stylized Christmas tree on this cover is the new hopeful 45RPM, thick-spindle player. They were in fact clever, quiet, and efficient devices, each one with a fast and fail-safe record changer built in. But as with the ill-fated Betamax video cassettes, a superior technical system in itself doesn't assure success. It's all marketing, marketing, marketing. And though CBS failed in the struggle against RCA for the color TV standard, it did win out in the LP 33 vs. the "holey" RCA 45.

The Cat in this issue finds that buying a rare jazz record is not all that different from buying a used car. I like this gag, suggested by Bob McGarvey.

And for the fifth time, The Cat dreams of the ideal Christmas stocking stuffer.

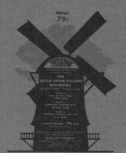

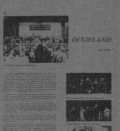
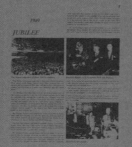

the record changer

DECEMBER 1949 35c

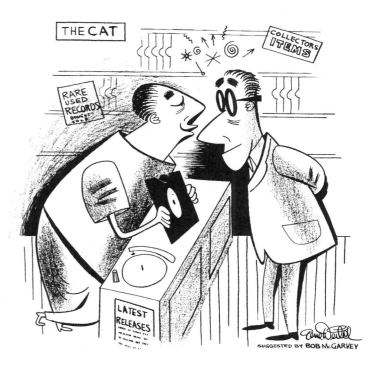

SUGGESTED BY BOB McGARVEY

"Lemme tell you something about this record—it was owned by an old lady who never played it faster than 20 RPM!"

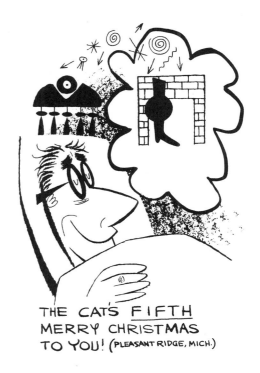

THE CAT'S FIFTH MERRY CHRISTMAS TO YOU! (PLEASANT RIDGE, MICH.)

1950

When a devoted jazz fan ever thought about traveling, it would naturally have to be where the traditional bands were playing. On a jazz-cat's globe, country names were unnecessary, just the gig spots. When I drew this it was in the early days of the Cold War, and I was still untutored in the labyrinthine ways of passports and visas. I got a triple dose of that nine years later when I was sent by a New York film producer to then-communist Czechoslvakia. But by amazing chance it turned out to be a hidden land of solid jazz. On my second day in the country I was taken by the Prague animation studio production manager (who is now my wife of 40 years) to a jazz concert in Prague's largest hall. A group of veterans who called themselves Prague Dixieland were playing that night. After the concert I was taken backstage to meet the band. A visiting American was for them an amazing event in that then-isolated iron curtain land. With their distance and isolation, I was amazed at how these musicians had so closely caught the American blues sound. But my greatest amazement came when I was introduced to the guitar player.

"By any chance," he said with quivering voice, "are you the same Gene Deitch who drew The Cat in *The Record Changer* magazine?" What??? Here I was, 3,000 miles from home, within a barbed-wire-ringed, apparently cut-off land, but this Czech guitar picker reached under his chair and from a battered old leather briefcase he pulled out a half-salami, a bottle of beer, and five copies of *The Record Changer* magazine! I knew at that moment that I had found a new home!

Because I was sent there to make cartoon films, and there was a complete lack of stereo recording facilities in Prague, I brought the very first stereo recorder into the country and recorded Czech traditional jazz bands throughout the years.

The Cat, seen as a dodderer in the Buddy Bolden Old Cats Home, basically predicts the CD and DVD records to come 50 years hence!

120

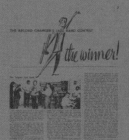

the record changer

JANUARY 1950 35¢

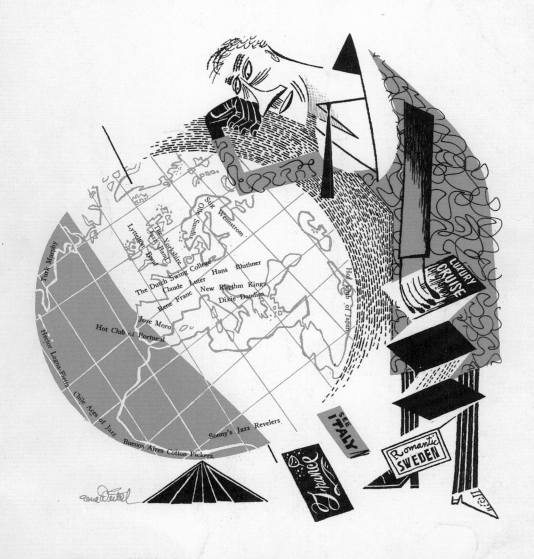

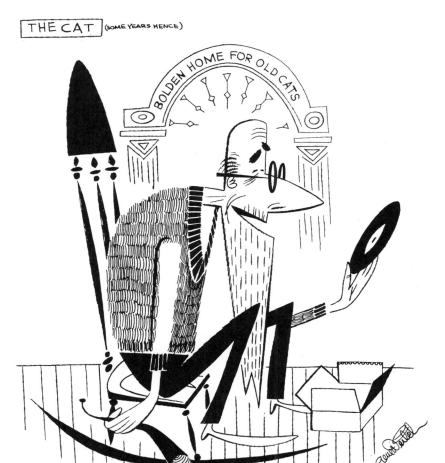

THE CAT (SOME YEARS HENCE)

"Gadfry, they've finally done it! . . . Unbreakable, no surface noise at all, never wears out, full range fidelity, plays at any speed, plays under water, needs no needle or amplifier, plays forward or backward, projects a picture of the band on the wall, and costs only two bits . . . Tsk! A pity my hearings gone."

122

My friend and animation colleague Cliff Roberts suggested that I draw an *RC* cover showing a New Orleans parade. I should have done something on this theme years ago! I tried to catch the spirit and feeling of movement with just a few figures.

This is one of the so-called "classic" Cat-toons. The Cat's vital signs reflected the ongoing battle of the record speeds, 78RPM, 33.3RPM, and 45RPM.

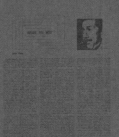

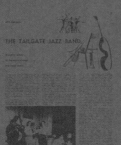

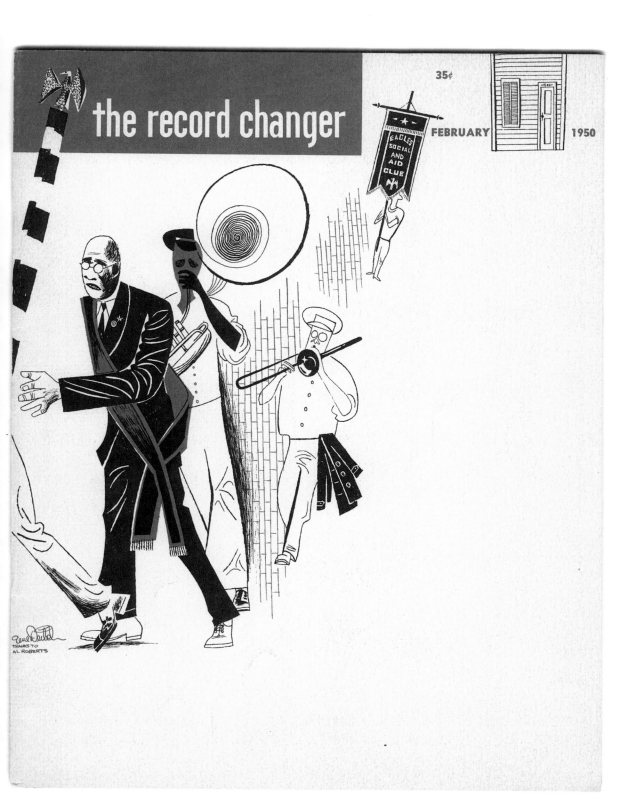

the record changer

35¢

FEBRUARY 1950

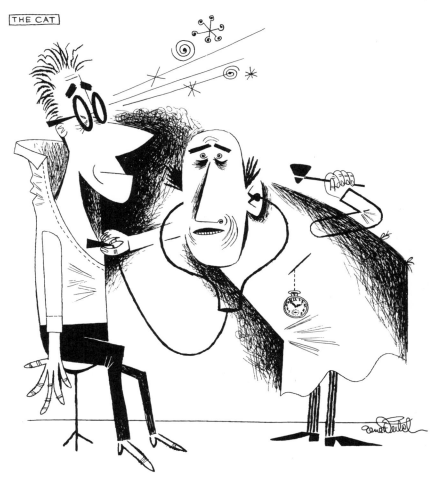

THE CAT

"My boy—You must be undergoing great emotional stress; today your pulse is 78 per minute—on your last visit it was only a little over 33; and the time before it was 45!"

124

This patchwork design was partly inspired by some Paul Klee designs. I stole plenty of other details from him in some of the little doodads throughout the magazine. Note that I inserted a photo of Muggsy Spanier's band in there. He was one of my white favorites at the time, but Sidney Bechet (inserted just one square down from The Cat) was the real thing!

The Cat faces another life-threatening situation, and I am proud that under the circumstances he is still speaking grammatically correct English!

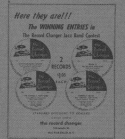

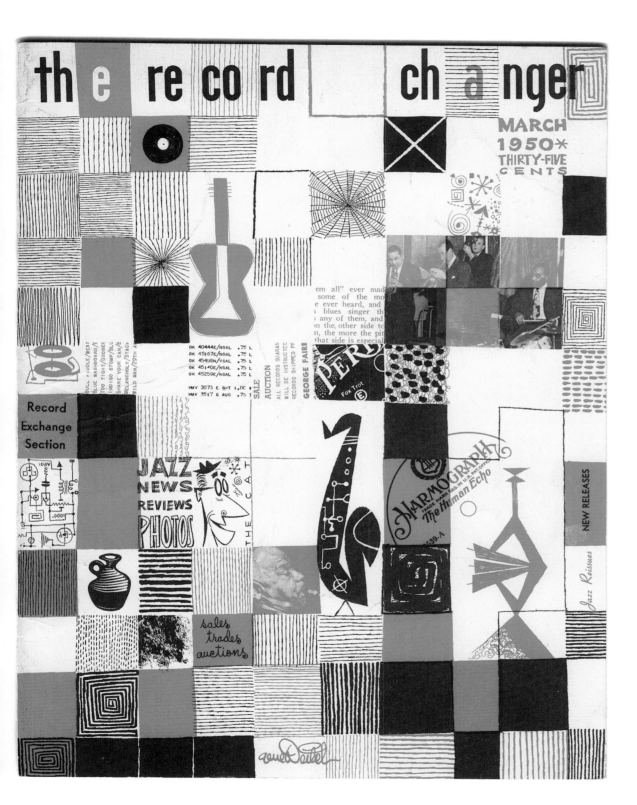

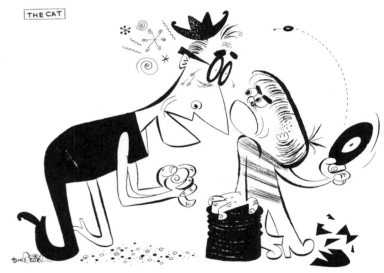

"Yes, sonny, I know your daddy gave you the pile of records to sail—and I'm sure he is bigger than I; but wouldn't you like the nice man to buy you a real model airplane and maybe a big strawberry soda?"

"Rocks in My Bed, Crickets All in My Meal!" This was a design to evoke an urban aspect of the blues. But what do the little symbols mean? With a champagne-glass-shaped head, things can't be all that bad.

The Cat sprouts extra fingers to express his joy after a visit to "Mecca." All lovers of classic jazz know that some of the best stuff was played by Black marching bands at traditional New Orleans funerals!

 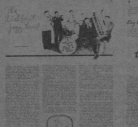

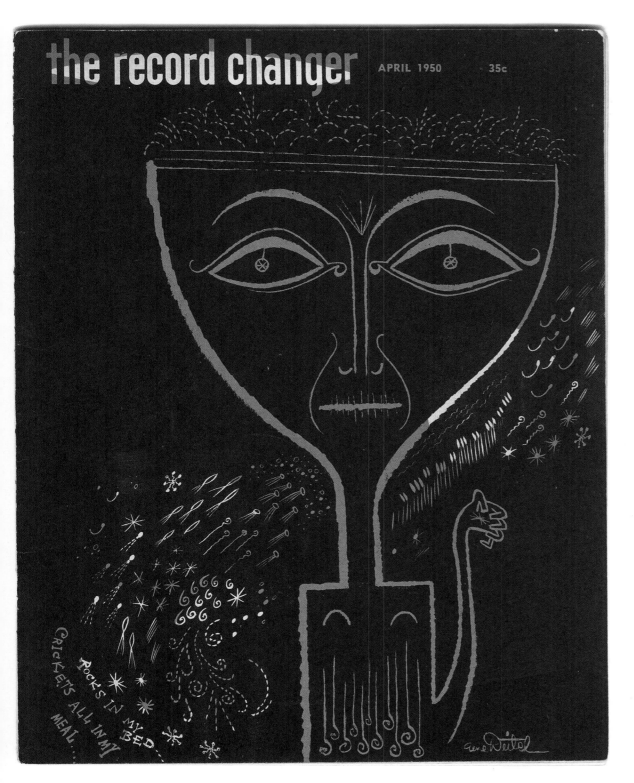

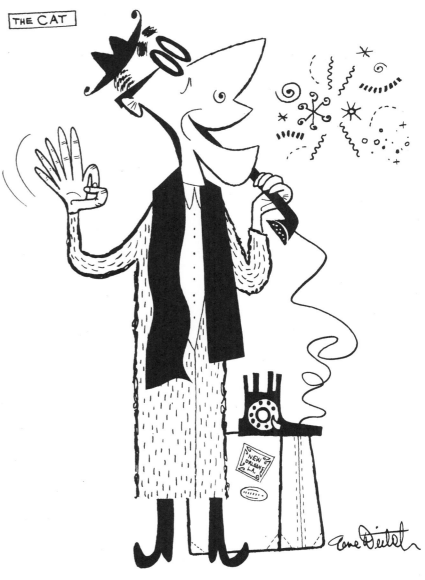

THE CAT

"Man, I Really Had A Ball In New Orleans;---Five Funerals!"

My cover for May was a semi-abstraction, perhaps with a bow to graphic gurus György Kepes and Paul Rand. I greatly admired their dynamics.

The Cat, however, is in a complete funk, as the very worst has occurred in his home. Will his children survive this incident?

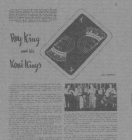

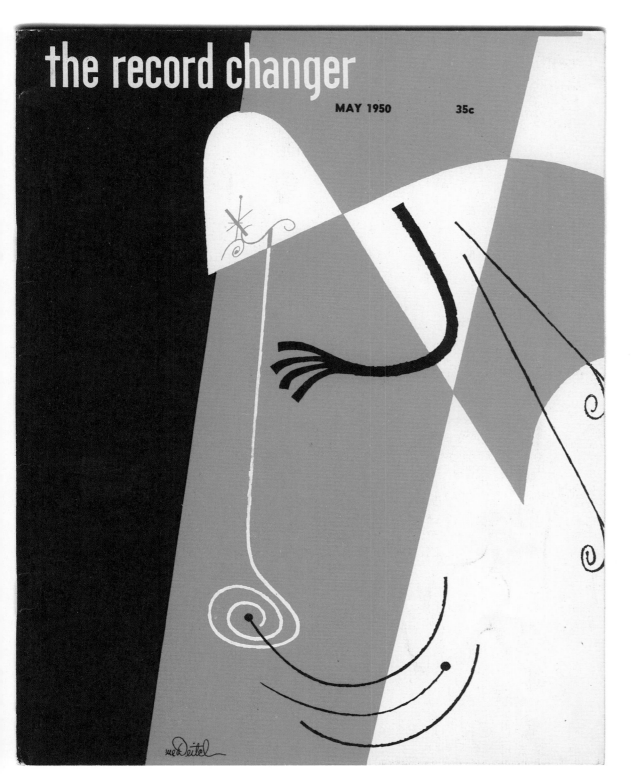

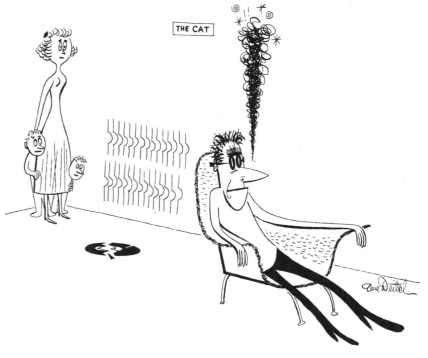

My cover graphically acknowledges the arrival of television, with the assumption that even jazz will appear on the flickering screens. The bank of studio lights in the design was made with ordinary notebook reinforcements.

the record changer

35c JUNE 1950

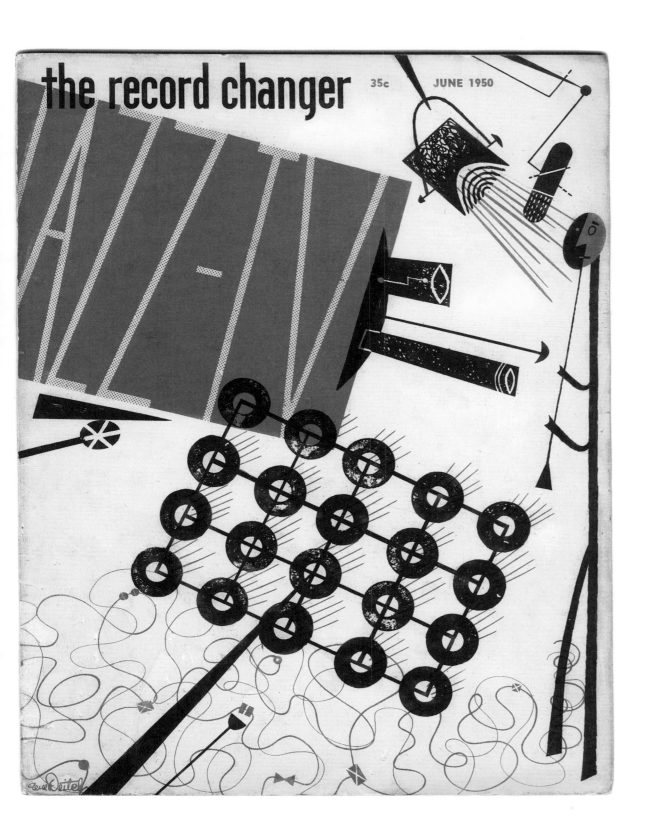

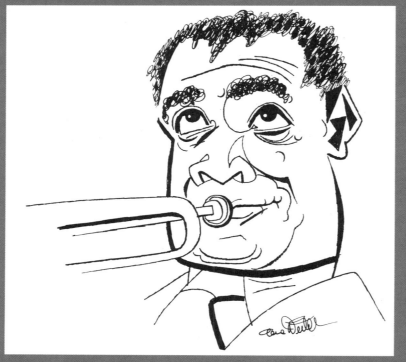

132

I didn't do a cover for this double-issue celebrating Louis Armstrong's 50th birthday, but I did a portrait of him for the inside, and a special drawing of The Cat preparing Satchmo's famous recipe for red beans & rice, plus even The Cat's extraordinary suggestion at how Louis might improve his trumpet playing.

In another Cat-toon, the devoted father reads the right kind of bedtime story to his kids.

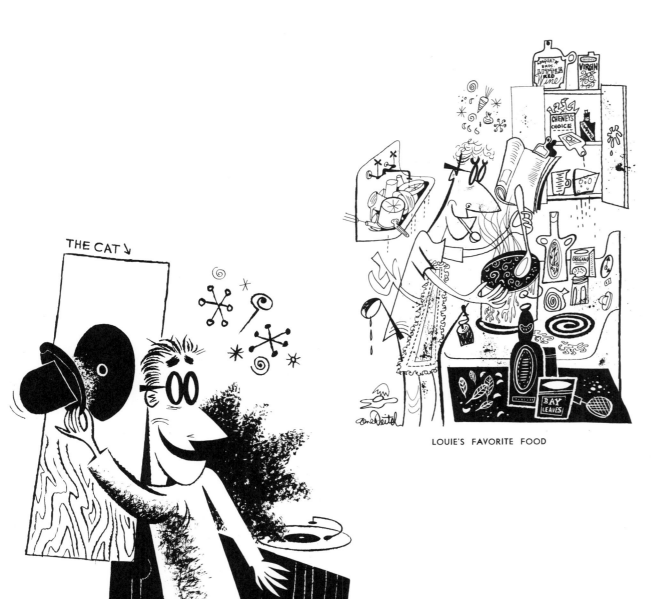

THE CAT ↓

"Gad, Louis—if only you knew how great you sound, wah-wah style!"

LOUIE'S FAVORITE FOOD

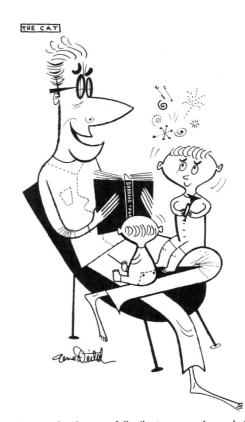

THE CAT

"... all at once the rowdy dancers fell silent ... and as rhythm section settled into a rocking stop-time, Louis raised his golden horn to his lips ..."

I further developed my portrait of Jelly Roll Morton for this cover and surrounded it with symbols of his personal schtick, mainly inspired by his 1938 Library of Congress recordings.

The Cat has become used to nursing a single drink all night in order to hold onto his table at a jazz club.

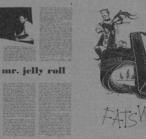
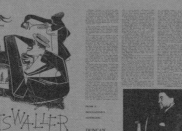

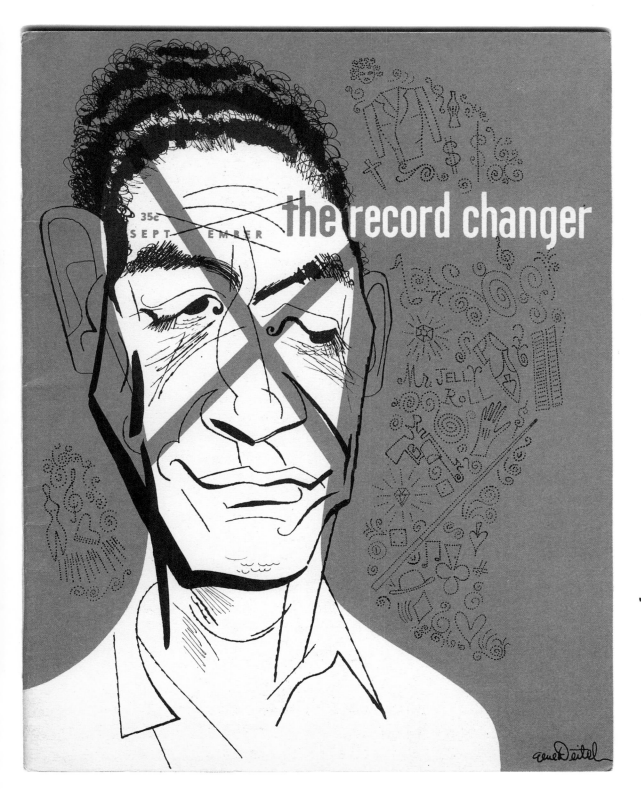

the record changer

35¢ SEPTEMBER

Mr. JELLY ROLL

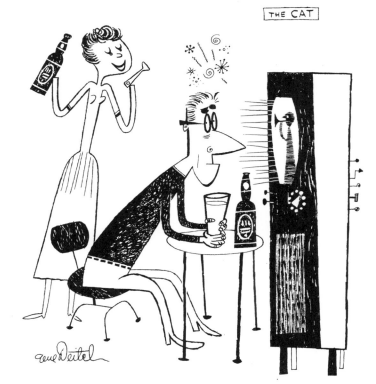

THE CAT

" FOR HEAVEN'S SAKE, DEAR; WE'RE AT HOME ! YOU CAN DRINK THE BEER ! "

The Cat's "Map of The U.S." pinpoints all the important jazz locations in the country at that time. My cartography was traced from one of my old school atlases.

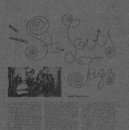

the record

changer

OCTOBER 1950 35c

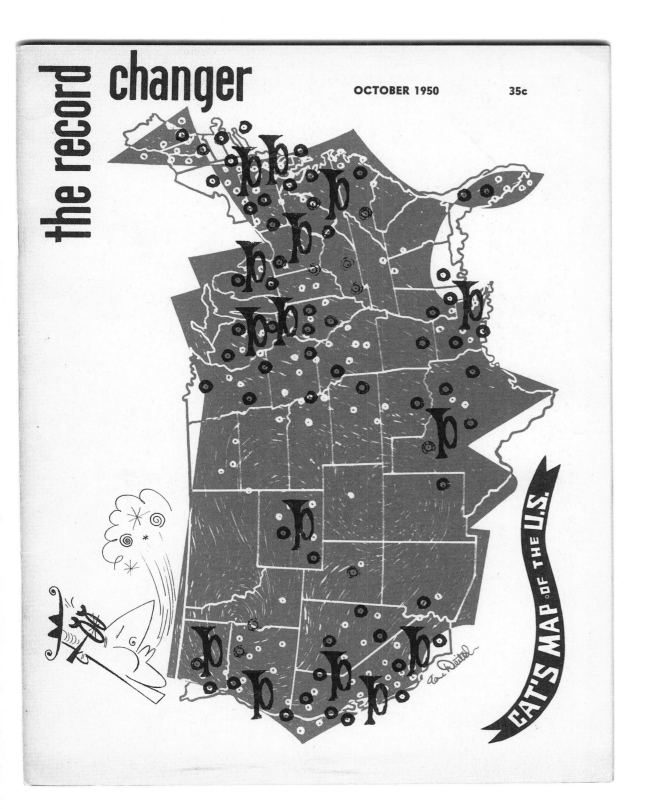

CAT'S MAP OF THE U.S.

This issue had no cover by me, but a single Cat-toon showing how difficult it was for him to get used to receiving tiny packages of 45s from the mailman. But at least the little discs were basically unbreakable.

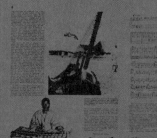

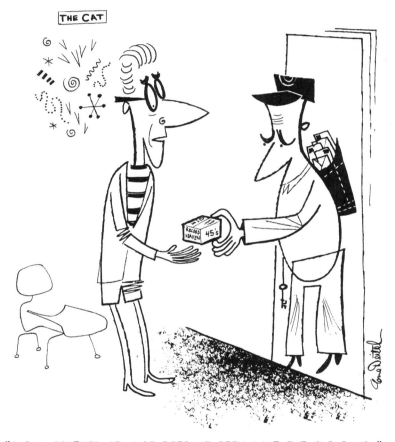

"GAD! SOMEHOW IT JUST DOESN'T SEEM LIKE THE OLD DAYS!"

This cover, front and back, was a Christmas extravaganza. It was a genuine mobile, with numbered parts that could be cut out and hung from wire coat hangers or knitting needles! The Cat's illustrated instructions were on page 15.

Otherwise, The Cat dreamed his standard Christmas dream for the sixth time in the *Changer*.

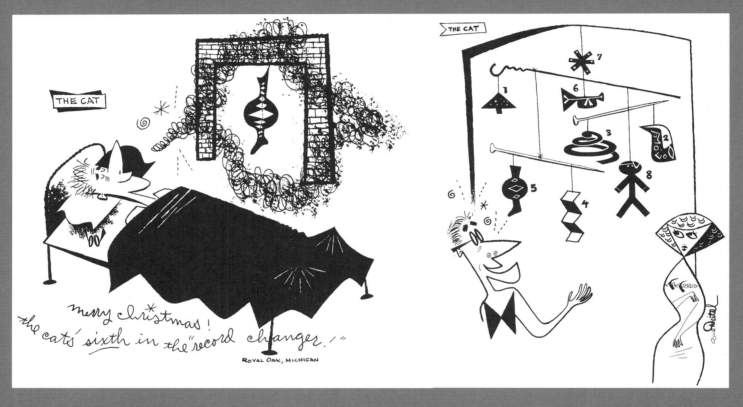

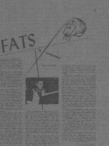
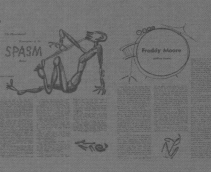

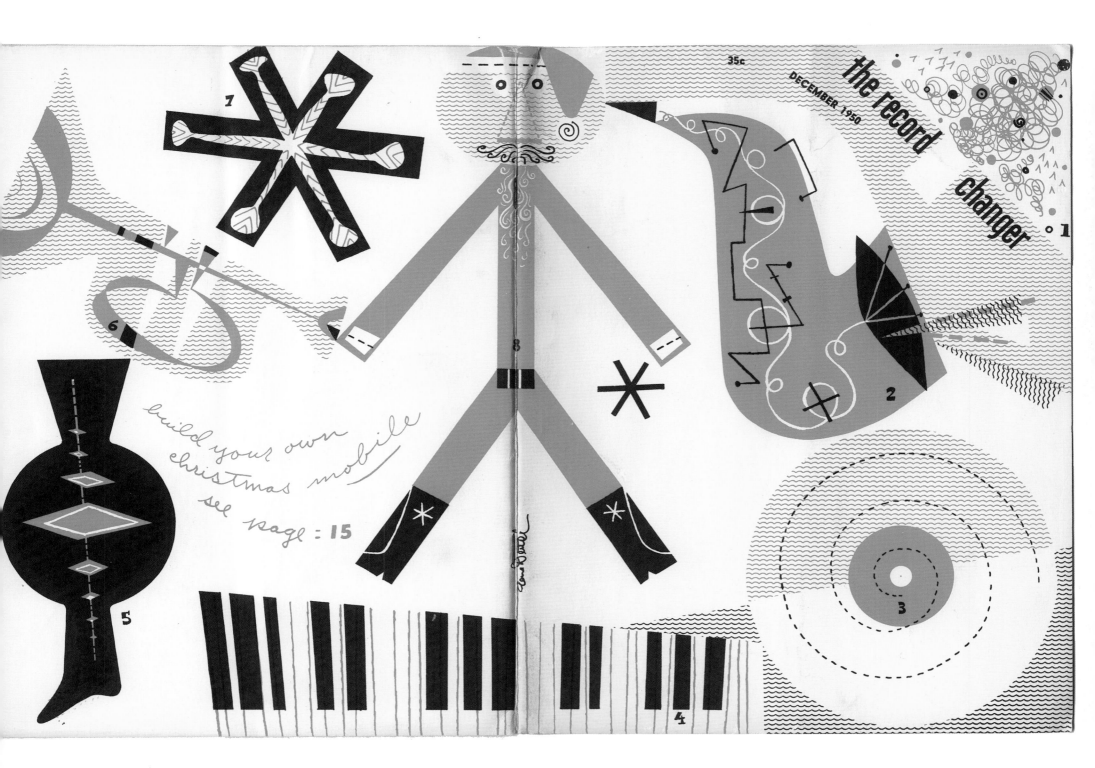

build your own
christmas mobile

see page : 15

1951

This was my final cover for *The Record Changer*. It was as if Picasso or Braque played in the "Hot Damn" jug band.

I had finally met Bill Grauer in New York, and I was not thrilled by his statements. I'd been dismayed over the past year to see more and more space in the magazine devoted to the heresy of modern jazz, and still being a stubborn Luddite, I decided to quit the *Changer*. Perhaps there was more to it. My animation career was in full flower, about to take up a new job at the newly established UPA/New York studio, where I would become the Creative Director, and also planning my own newspaper comic strip. Perhaps it was best that I left when I had laid down a sufficient legacy to jazz fanhood. But it was not the end of The Cat. At least one more appeared in the February, 1951 issue. I thought it was funny and true at the time, with the Cold War in full fury. I later discovered that there was plenty of good jazz in Russia!

I continued to draw The Cat over the years, up to the present, for various personal requests and for different jazz publications. Many of the drawings, never published, appear in this book for the first time.

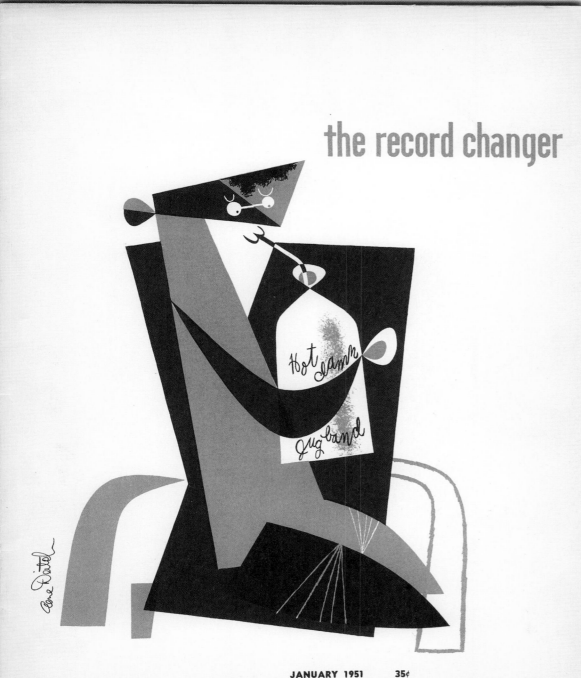

the record changer

JANUARY 1951 35¢

"OH WELL, THE RUSSIANS NEVER MADE ANY JAZZ RECORDS WORTH A DAMN ANYWAY !"

(Since I made this drawing in 1951, I've learned that Russian jazz musicians have made some very good jazz records indeed!)

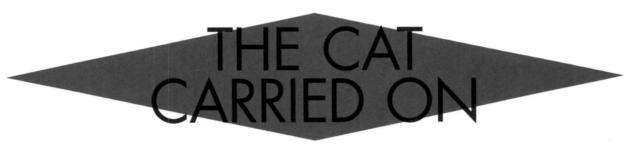

THE CAT CARRIED ON

A GALLERY OF RELATED CAT-TOONS

148

Here is one Cat-toon that originally appeared in the *RC*, but was later revised for another publication, with a completely different gag-line. The original "33-45-78" gag, which at the time referred to "the struggle of the record speeds," has little meaning today in the era of CDs. It would be interesting to hear from readers which gag they like best.

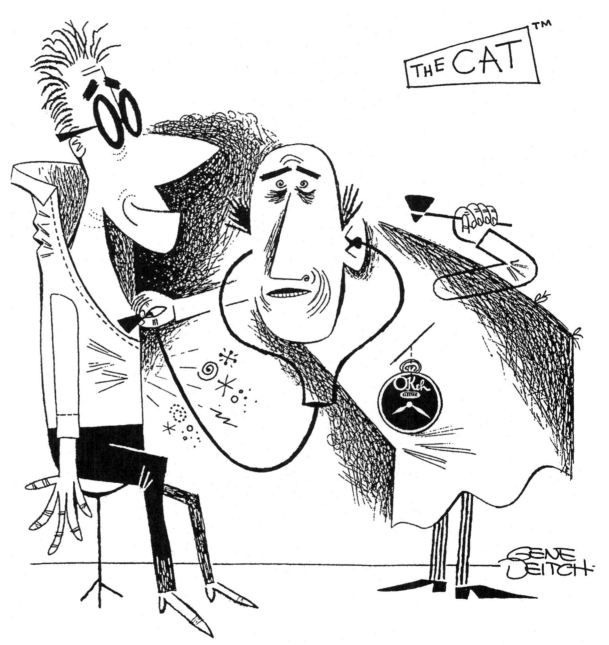

THE CAT ™

"JUST WHEN I THINK I'VE HEARD EVERYTHING, HERE'S A STOMACH THAT GURGLES LOUIS' INTRO TO WEST END BLUES!"

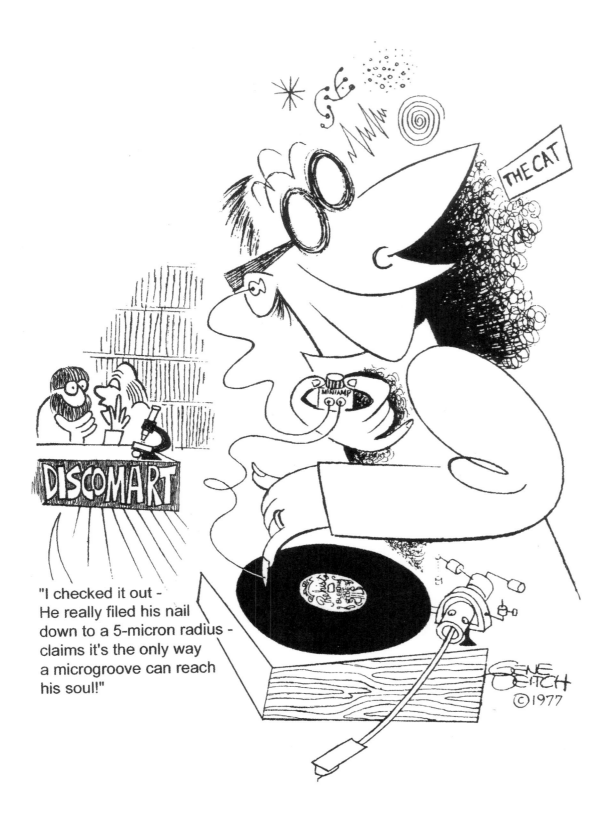

"I checked it out - He really filed his nail down to a 5-micron radius - claims it's the only way a microgroove can reach his soul!"

I made this drawing for my son Simon, who was working in an LP record shop at the time. The introduction of LP records was a mixed blessing for purist jazz record collectors. They were touted as being unbreakable, but if dropped in just the wrong way, they would split. And it was just as catastrophic to sit on an LP as on a shellac record. Another claim was that LPs eliminated surface noise. On the first play, maybe, but vinyl plastic was static-electric-prone and was a powerful dust magnet. All manner of magic, anti-static cleaning fluids, potions, special cloths, wetting tubes, plush brushes and prayer shawls were introduced at high prices. None of them worked.

Storyville 127

1 October 1986 95p

This was my first cover drawing for the British magazine *Storyville*. This was in answer to a request by Laurie Wright that I do a cover for his 21st anniversary issue.

"Holy Modem! I've now reached 21,000 trumpet-breaks, cross-referenced by open-horn, muted, pre-& post-Louis, I have 21K left on the data disk, and Storyville is 21 years old!"

THE CAT ™

SchawLaser

SL

GENE DEITCH ©1987

"GADZOOKS! THIS TAKES STEREO TO A WHOLE NEW LEVEL!"

I drew this for Arthur Schawlow, my oldest Cat fan, gag contributor, and by the way, Nobel prize winner for the invention of the laser!!!

151

152

When did CDs first appear? Was this Cartoon prophetic, or was I just jumping onto the hot jazz band wagon?

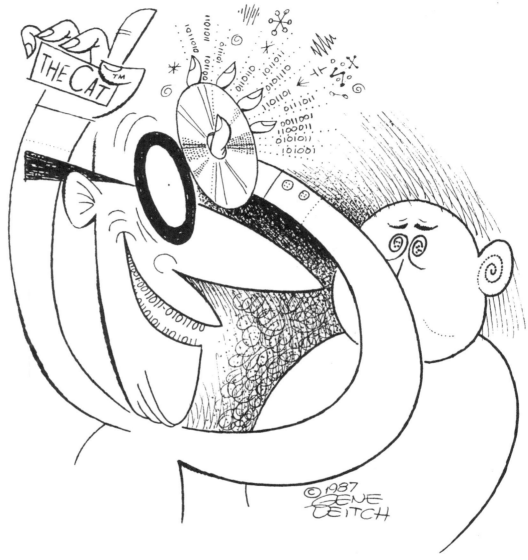

"GADZOOKS! - This laser-scanned, digital reprocessing of King Oliver's SNAKE RAG is so clear you can hear young Louis Armstrong say, 'If I can just make it through this next two-trumpet break, I can make in anywhere!'"

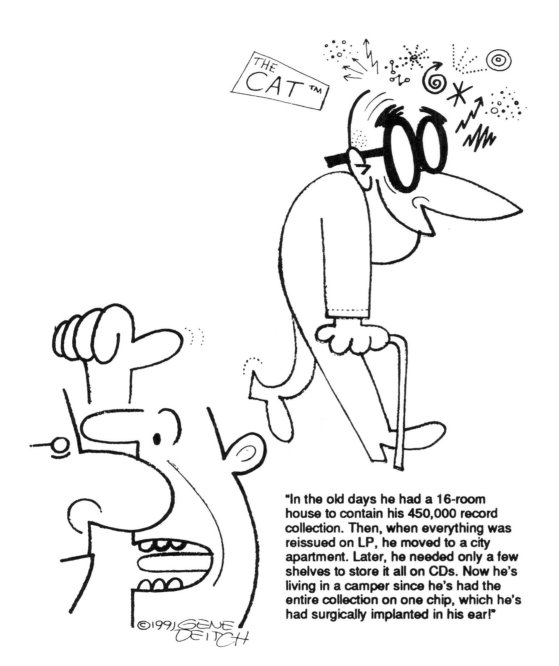

THE CAT ™

"In the old days he had a 16-room house to contain his 450,000 record collection. Then, when everything was reissued on LP, he moved to a city apartment. Later, he needed only a few shelves to store it all on CDs. Now he's living in a camper since he's had the entire collection on one chip, which he's had surgically implanted in his ear!"

©1991 GENE DEITCH

The Cat adjusted his living quarters in exact sync with the march of technology.

Laurie Wright, publisher of *Storyville* magazine, was writing a book about Fats Waller, and he asked me to do a drawing for the first page. This is it, and now you know who Laurie Wright is, even if ol' Fats didn't!

"LAURIE WRIGHT?-NEVER HEARD OF HIM."

I made this sketch for my newsletter, "The Occasional Deitch," as a celebration of Czech jazz. I since inserted it in various letters, and also reprinted it in my book, *For The Love of Prague.*

This is a quick drawing I did for *Tailgate Ramblings*, the magazine of the Potomac River Jazz Club, near Washington, DC. It appeared on the cover of their April 1997 issue. During the whole of the 1990s, *Tailgate Ramblings* reprinted just about all of the existing Cat-toons. I have no idea where they got them from. It's a sharp magazine, still doing well as I write this. Besides the magazine, the PRJC sponsors jazz bands and events throughout the tear. A good bunch of traditional jazz lovers.

156

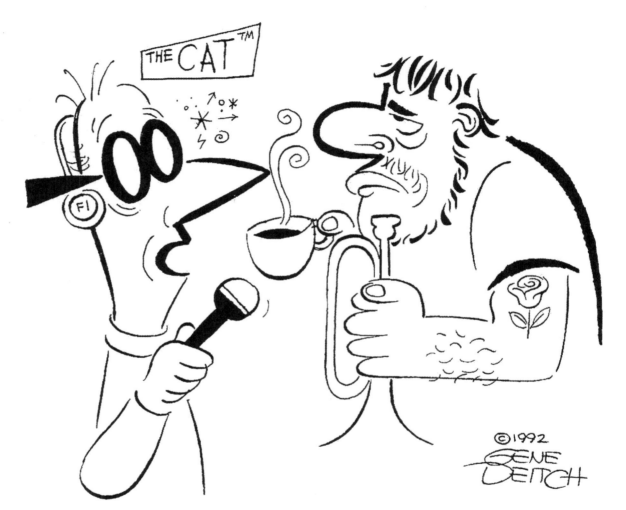

"BUT YOU SAID IF I SLIPPED YOU A LITTLE TEA YOU'D LAY DOWN A FEW CHORUSES FOR ME!"

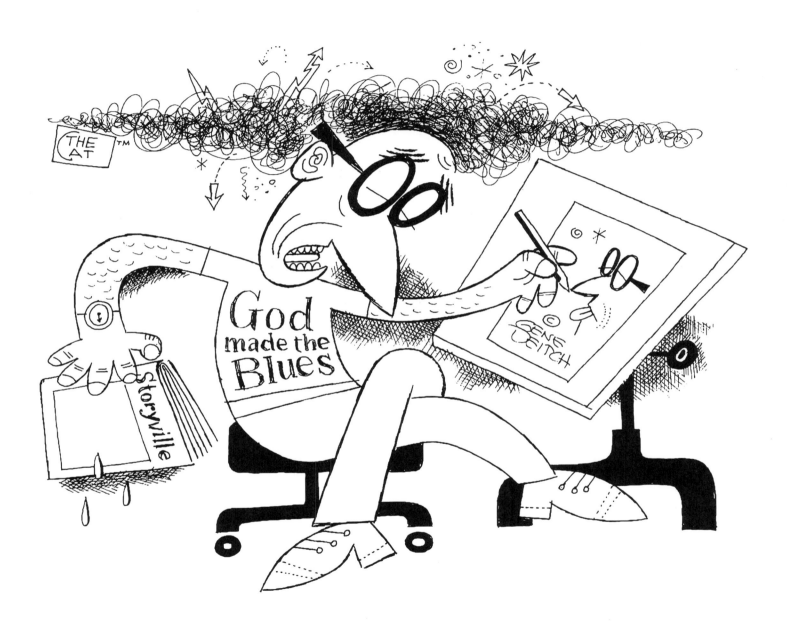

I made this drawing for the cover of the final issue of Laurie Wright's *Storyville* magazine. It was a sad event. Laurie published his scholarly British version of the *RC* through 162 issues. It ended in June, 1995.

This is one that appeared on the cover of *Tailgate Ramblings* magazine in 1996, and pretty well reveals The Cat's idea of open-mindedness.

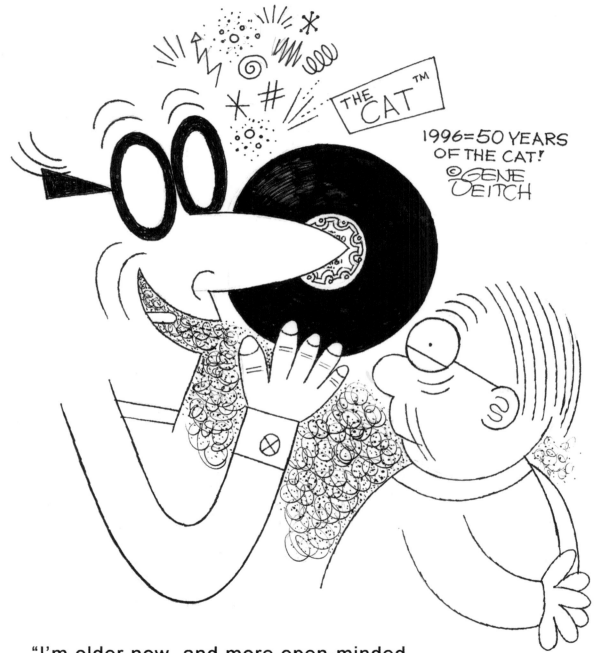

"I'm older now, and more open-minded....
I'm moving my acceptable date up from 1926 to 1929!"

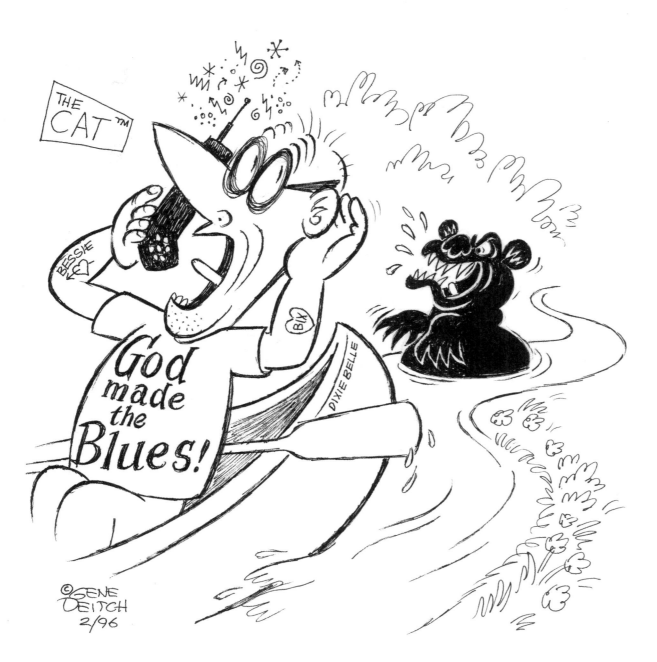

This is a rough drawing I made for the Potomac River Jazz Club. Devoted New Orleans jazz collectors will note the reference to Jelly Roll Morton's *Dead Man Blues* record.

159

160

Kevin Coffeyn was a combo fan of both my *Record Changer* drawings and also of my TV serial, Tom Terrific with Mighty Manfred the Wonder Dog, thus this schizophrenic drawing for him, forcing a gag out of the similarity of his name to the caffeine in coffee.

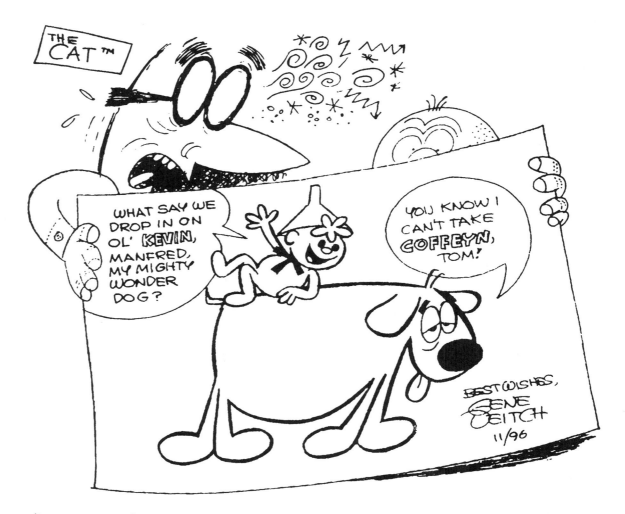

"WHAT?? YOU MEAN YOU TRADED AN ORIGINAL 1923 OLIVER GENNETT RECORD FOR THIS STUPID DRAWING???*!!*"

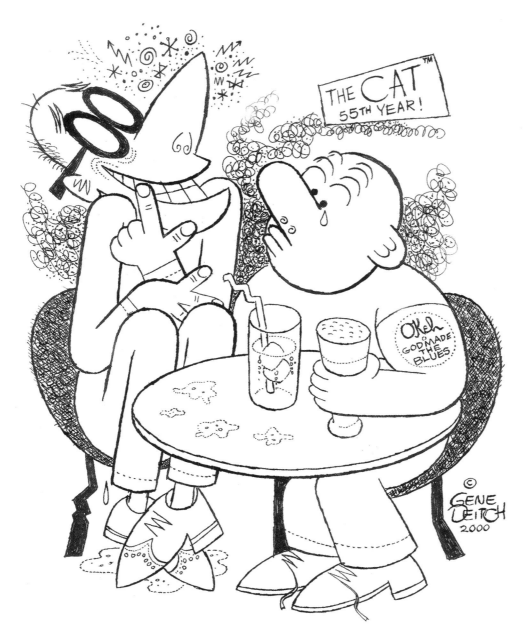

"I was there the night John Lee Hooker ate his guitar!"

I made this drawing for the CD booklet of my John Lee Hooker 1949 recordings. The rediscovery and release of these long-lost recordings was the high point of life at the end of the 1990s. For the full story of this incredible performance and how it came to light, see the last few pages of my newsletter, "The Occasional Deitch," at www.genedeitch.com.

A great Cat fan, Glenn Bray asked me for a "really Crazy, Wild Cat," so I made this drawing for him. The reference is to Louis Armstrong's recording of "Muggles." Today, Harry Potter fans will take this as meaning "non-witches," but in Louis' day Muggles meant marihuana. But there is a double joke here, because 78RPM shellac records did have a special smell, and if you managed to finally get that long-yearned-for rare Louis record, you would indeed get a high just from sniffing the label!

162

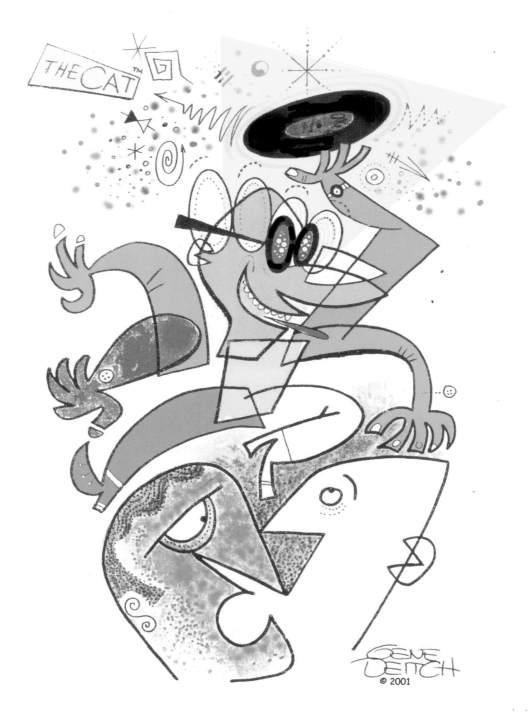

"He gets a cheap high just from sniffing the label on Louis' Muggles!"

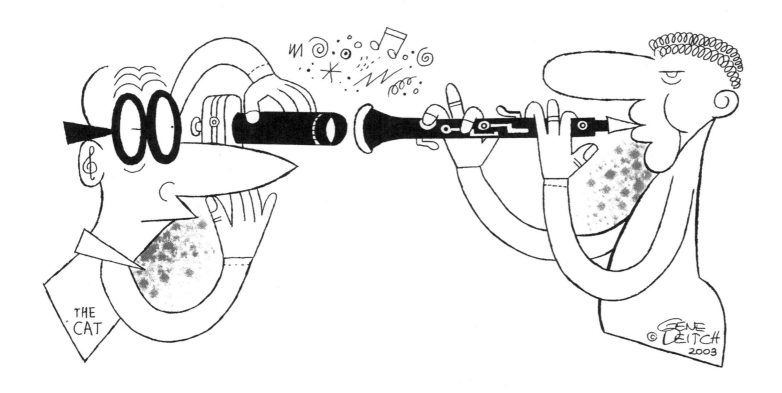

I made this drawing especially for Ray Avery, once the owner of a great record collectors' shop, and later a great photo documentarist of star jazzmen.

For years I tried earnestly to fulfill all requests for an original drawing or sketch, but when my workload wouldn't permit it, I'd make a sort of all-purpose Cat-toon, to which I could just fill in the fan's name, and send off a photocopy. This was one of them.

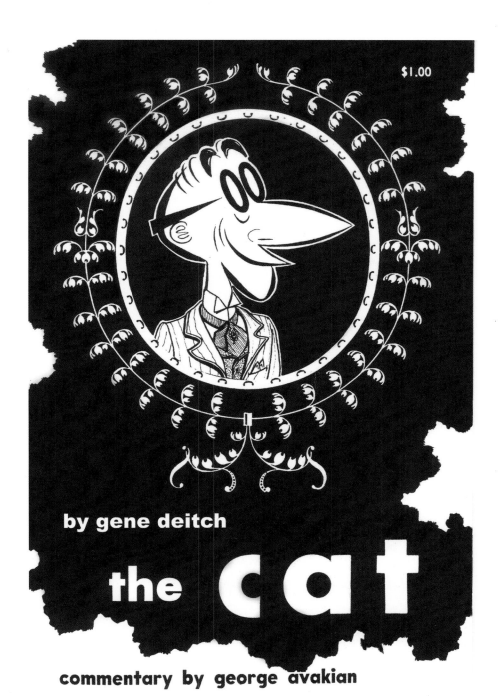

$1.00

by gene deitch

the cat

commentary by george avakian

This was the cover of the first printed collection of Cat cartoons, published by *The Record Changer* in 1948, with commentary by the famous jazz writer and promoter, George Avakian. It is extremely-extremely rare. But even if you got hold of a copy, it could not compare with the book you now hold in your hands! That book came out when I was only half-way through my *Record Changer* work, and it printed none of the covers. This book is the one and only comprehensive and complete collection. If you want more than this, then you really are a manic-compulsive!

I did covers for the two volumes of *The Index to Jazz*, a compendium of then available or known authentic jazz records. This cover design was inspired by some images of the Swiss artist Paul Klee, but given an African musician twist in my own design. I used pen and ink plus texture made by printing with a sponge, a technique I used often on *RC* covers. The second *Index to Jazz* cover was a photo montage, featuring a trumpet, but perhaps not so graphically interesting as this one.

"Storyville"

New Movie To Show Real History Of Jazz!

After many feeble attempts, Hollywood has at long last put into production what will be the first authentic motion picture on the early days of New Orleans jazz. All lovers of Negro music will be happy to know that every effort has been made to accurately record the great saga of hot jazz.

The film consists essentially of six musical sequences with a plot weaving throughout. It is based on the life of Buddy Bolden, admirably portrayed by trumpeter Dizzy Gillespie; tracing his career from the day in his early teens when he accidentally discovered jazz by rubbing two Bamboula sticks together, to the time he went insane. This occurs during a passionate scene while Bolden is improvising the frenetic final chorus to *Ride Red Ride*. No longer able to hit B above high C, and thwarted in his love for a white rice planter's daughter, he collapses in agonizing frustration and falls beneath the shuffling feet of the dancers.

Of the musical numbers, the first is an interesting levee sequence in which several stevedores set down their cotton bales and turn out to be the King Cole Trio, piano and all, playing wonderfully on *Blues in the Night*. The Mills Brothers also appear in this scene as does the Cab Calloway Band which arrives at the levee on an African slaver. The band is cleverly ornamented in native costume with the Cab decked out as a Witch doctor. Their entrance is very impressive as

the ship slowly pulls into the dock, with the band on deck throbbing out *Minnie the Moocher.*

After an interesting Honky tonk interlude in which Hazel Scott plays some amazingly fast ragtime on the Novachord, there is an atmospheric scene at the old Fewclothes Cabaret in which a septet from Count Basie's band appears. The Count plays a huge, barrel-shaped piano with a glistening gut-bucket at one end. Right after a terrific riff-arrangement of *Royal Garden Blues*, there is a huge brawl over a dice game in which Freddie Keppard is slashed to death. This, of course, makes a perfect transition for the beautifully conceived Funeral sequence. In this, the aged New Orleans veteran Bunk Johnson appears to lead the funeral march, accompanied by the entire Boston "Pops" Orchestra, in black-face. The whole group stomps back from the burial with a great arrangement of *Tiger Rag*, scored for the film by José "Jo-Jo" Iturbi. Of course, the sound track for old Bunk's part was recorded by Cootie Williams; and the effect worked out very nicely except for a few hardly noticeable spots where Bunk was not quite able to follow Cootie's intricate buzz-bugling.

This sweeping section of *Storyville* is climaxed by a full-scale revival sequence, and the whole cast is augmented by the Hall Johnson Choir as the congregation singers. They all do a lush, symphonic version of *Swing*

Low, Sweet Chariot. The whole breathtaking scene captures the mood and mighty folk quality of the Negro race, with pathos and social protest in every savage bar.

Then and there everyone decides to put the show on the road, and a collection is taken up to spread the Negro's great music. One white woman who has been watching the revival writes them a check for $10,-000,000 to the great jubilation of the cats.

And in the final majestic scene the entire company is aboard a Riverboat, heading up the Mississippi to Chicago, playing a rocking, Boogie-Woogie version of *Saint Louis Blues*. Here we feel the deep significance of Jazz . . . moving up the river to the great metropolis of Chicago . . . to be spread over the entire civilized world! Perhaps a hint of a sequel . . . the further chapters in the history of hot . . . can be seen in this last stirring scene.

In Hollywood's effort to make this production complete and authentic, every available jazz artist and group was filmed. In fact, a few cottonfield and chain gang sequences with Leadbelly, and a couple of numbers by Kid Ory's band were left out of the final picture because of over-length. However, there is so much good music and folk-history left, that jazz fans everywhere will feel that at last, the movies have done right by them!

gene Deitch

Gene Deitch wrote a gag review of a nonexistent movie he called *Storyville* that ran in the October 1945 issue of *The Record Changer*. We present it here for the first time since its original publication exactly as it appeared almost 60 years ago (Deitch's byline with the small "g" is an in-joke.). Many readers took the review seriously and were so outraged that they agitated to form picket lines to protest the disastrous idea of a movie. Traditional jazz fans took their jazz seriously.

GENE DEITCH

Gene Deitch is an Oscar-winning animation film director and scenarist. Before he entered his career proper as an animator and cartoonist, he discovered an opportunity to express his passion for traditional jazz and his love of drawing by contributing to a jazz collector's magazine in the 1940s called *The Record Changer*, where he drew many of the magazine's covers, as well as writing and drawing the iconic cartoon panel "The Cat," from 1946 to 1950.

In 1946 he started as an apprentice in the then cutting edge Hollywood animation studio, UPA, working as an assistant Production Designer on the first Mister Magoo cartoons for Columbia Pictures. Within five years he rose to be Creative Director of UPA's New York studio, where, among his many gold-medal winning films, he directed his famous Bert & Harry Piels beer commercials. His TV commercials were the first ever shown at the New York Museum of Modern Art; an entire month of screenings in 1954 (MOMA hosted two more homages to Deitch's films, most recently in April 1996). In 1956 CBS purchased the Terrytoons animation studio and named Deitch as its Creative Director. Under his supervision and direction, the studio produced 18 CinemaScope cartoons per year for 20th Century Fox, and won its very first Oscar nomination. He created and directed the Tom Terrific series for the nationwide CBS *Captain Kangaroo* show. Tom Terrific (with co-stars Mighty Manfred the Wonder Dog and the villainous Crabby Appleton), was the first animated serial for network television. In 1958 he set up his own studio in New York, Gene Deitch Associates, Inc. It was there that he was approached by Producer William L. Snyder of Rembrandt Films, who made the offer he could not refuse. Snyder offered to finance Deitch's studio's storyboard of Jules Feiffer's story *Munro*. The catch was that it had to be produced at Snyder's facilities," which turned out to be in Prague, then the capital of communist Czechoslovakia. Deitch insisted on a contract guaranteeing he didn't have to stay there more than 10 days. Fifty-two years later he is still there.

Romance, an Oscar win for *Munro*, the opportunity to make the children's films he wanted to do, and Prague itself made the difference. Deitch almost immediately fell in love with the Prague animation studio producer, Zdenka, now his wife and colleague of 50 years, and with the stunning city of Prague. While living in Prague, Deitch has outlived the communists, won over 150 major awards for his children's films, and continued his lifelong passion for traditional jazz. His early recordings of John Lee Hooker, Pete Seeger, and numerous Czech jazz groups have all made recording history. His memoir, *For The Love of Prague*, by the only free American to live in Prague continuously during 30 years of the communist regime, is now in it's 5th edition.